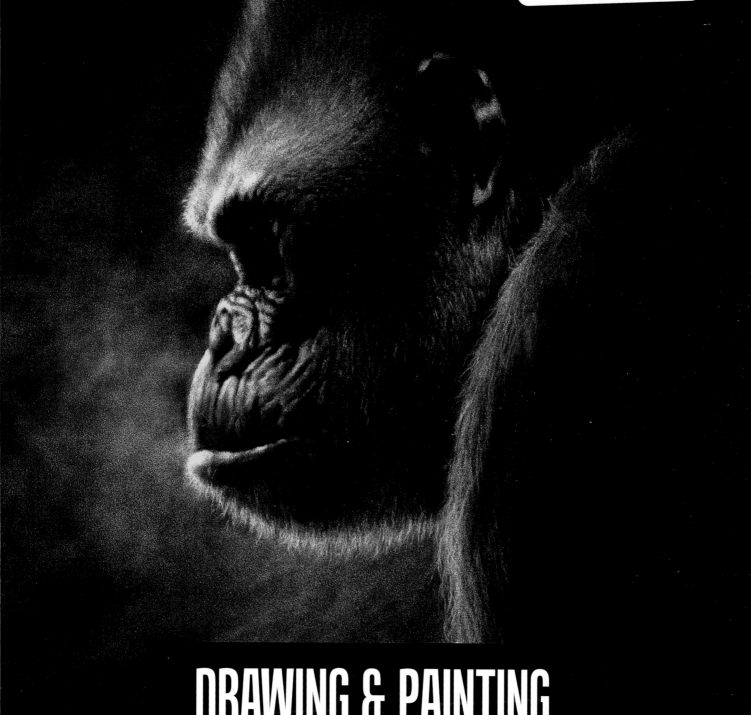

DRAWING & PAINTING
Wild Animals

Dedication

To Liz, for helping to make it all possible;
and to all the animals, past and present,
that have shared our lives and touched
our hearts.

DRAWING & PAINTING
Wild Animals

Vic Bearcroft

SEARCH PRESS

This edition published in 2019

Search Press Limited
Wellwood, North Farm Road,
Tunbridge Wells, Kent TN2 3DR

First published in 2012

Reprinted 2022

Text copyright © Vic Bearcroft 2019

Photographs by Debbie Patterson at Search Press studios
Photographs and design copyright © Search Press Ltd, 2019

ISBN: 978-1-78221-787-9

Suppliers
If you have any difficulty obtaining any of the materials and equipment mentioned in
this book, then please visit the Search Press website for details of suppliers:
www.searchpress.com

You are invited to view the author's website:
www.vicbearcroft.co.uk

Acknowledgements

I would like to thank these organisations for allowing me close
access to wolves and big cats over the years, which has greatly
improved my understanding of these magnificent animals:
The UK Wolf Conservation Trust
The Wildlife Heritage Foundation
The California Wolf Center

In addition, Andy Porter, for his photograph of a clouded
leopard that provided my reference for the painting on the
cover of this book; and Carol Bonsor and Sue Van Silver, for
allowing me use of their African painted dog photographs.

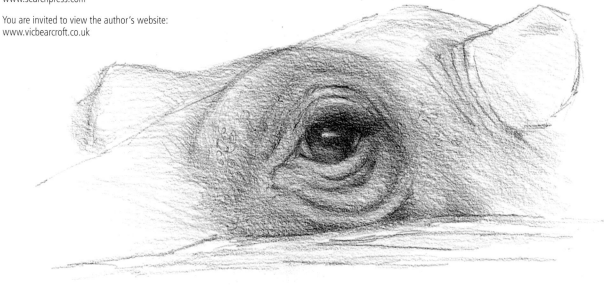

Page 1
Gorilla
A pastel painting of a western lowland gorilla on
black velour paper.

Page 3
Lion
Another painting in pastel, this time of a male lion
on sand-coloured velour paper.

Opposite
Bongos
A female bongo (a type of African antelope) and her
calf on watercolour paper, worked with watercolour
and coloured pencil.

Publishers' note
All the step-by-step photographs in this book feature the author,
Vic Bearcroft, demonstrating his drawing and painting techniques.
No models have been used.

Contents

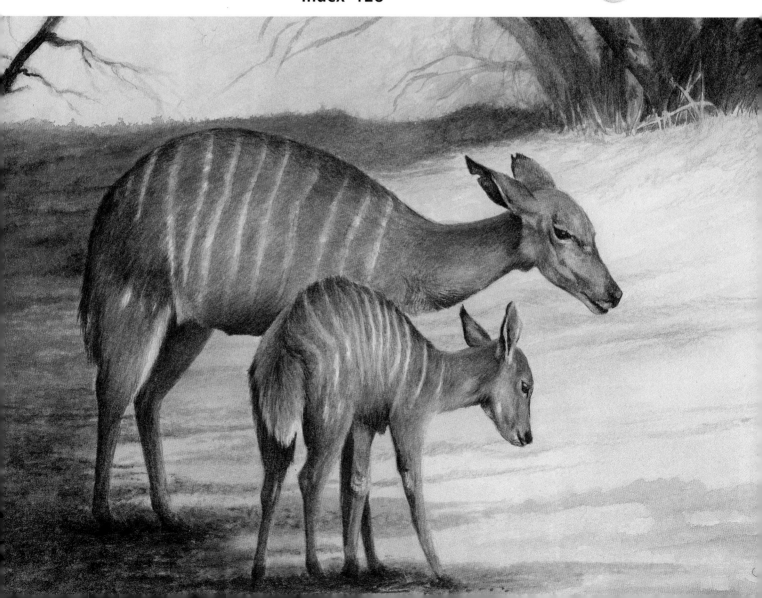

Introduction

Whenever I visit a wildlife sanctuary or a zoo, I am torn between wanting to spend time relaxing and looking at the animals – their movement, behaviour, the texture and colour of their fur – and wanting to rush home to paint the ultimate wildlife masterpiece!

This happens to me all the time. I just can not help being inspired by things I see around me, especially animals. Of course, I am not alone in this respect; most animal artists have an affinity, not only for the animals they paint and draw, but also for the natural environment.

Sadly, for most of us, the best chances of seeing wild animals are in zoos, animal parks, or sanctuaries. Expeditions to see animals in their natural surroundings can be very expensive; even then you might not see those you are interested in at close quarters – if at all – as some of the most beautiful are also the most endangered.

There are, however, several well-run sanctuaries that not only rescue wild animals, but also have breeding programmes to release rare and endangered species back into the wild. Many of these sanctuaries also run photography or art workshops, to help fund their work. These workshops give photographers and artists a chance to study, sketch and photograph the animals at close range. The animals themselves are usually content, being stimulated by regular contact with their handlers and keepers; and living in enhanced enclosures which provide further stimulation. This environment enables the artist to see the animals in a more natural state than you would in a zoo.

If you are not able to visit a zoo or animal sanctuary, then there are now some excellent wildlife documentaries on television, which also give you the opportunity to study features, movement and the natural environments of the creatures you wish to sketch.

In this book, I want to share with you my passion for drawing and painting wild animals, a well as the techniques that I have learned over the years. Techniques for creating realistic eyes, fur texture, wet noses, hooves, horns and – yes – faces too. I should say at this point that there are almost as many techniques in drawing and painting as there are materials. The techniques shown in this book are those that I use in my work.

As artists, we are – and should be – always learning. If we think we know it all, we can become complacent in what we do, and that will inevitably show in our paintings and drawings. I hope that you will practise the exercises in this book, especially using basic shapes to create your own animal drawings and paintings. I hope also that you will try the various demonstrations for yourself, and experiment by using different media for new effects.

Above all, I hope you will be inspired to take up a pencil, brush or pastel and capture the wonder and beauty of the wildlife that we used to see all around us. Drawing and painting wild animals is a pastime that the human race has been pursuing for thousands of years. I hope that we will still be able to see, draw and paint these precious animals for many, many years to come.

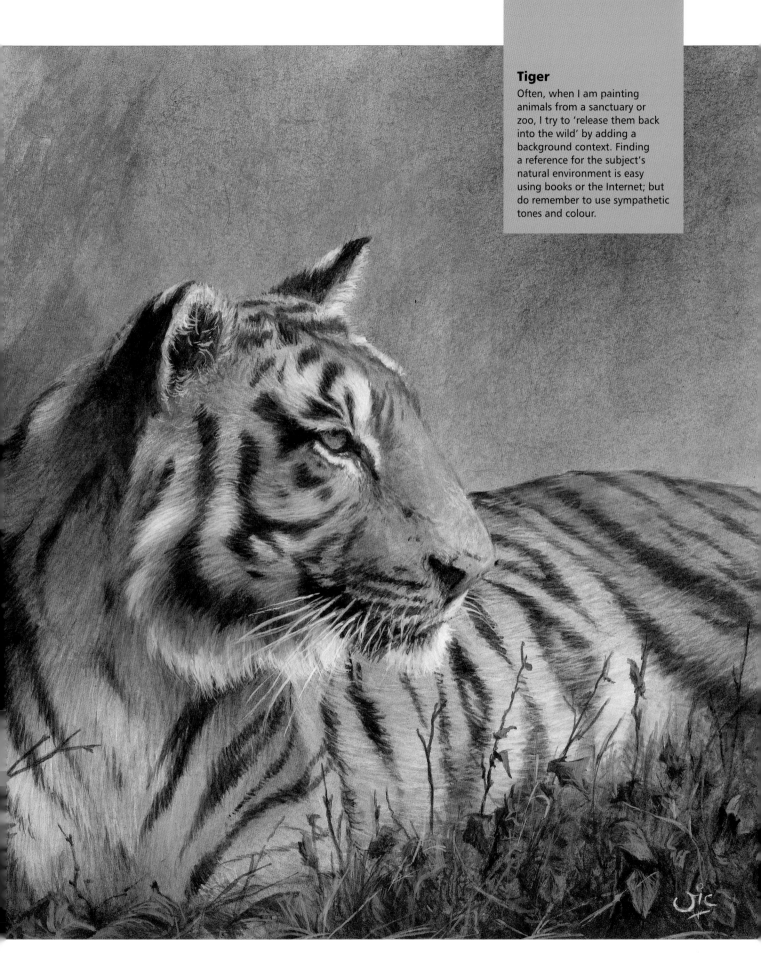

Tiger
Often, when I am painting animals from a sanctuary or zoo, I try to 'release them back into the wild' by adding a background context. Finding a reference for the subject's natural environment is easy using books or the Internet; but do remember to use sympathetic tones and colour.

Materials

It is not necessary to invest in a huge selection of equipment to enjoy drawing and painting wild animals. If carefully selected, a reasonably limited range of materials will see you through most projects, from sketches to complete paintings.

There always seems to be a vast array of materials to choose from, which can be confusing, especially if you are planning to try a new medium with which you are not familiar. The following pages aim to explain the basic properties of some of the materials you can use.

Drawing

CHARCOAL

Charcoal is made by slowly baking or burning willow twigs without air, so that they carbonise, rather than turn to ash. Vine charcoal and willow charcoal are essentially the same: although vine charcoal was traditionally made from vine twigs, both are made from willow twigs nowadays.

Charcoal is one of the oldest forms of drawing, having been used as far back as 30,000 years ago. Some of the earliest wildlife drawings were made by using charred sticks on cave walls.

Unlike graphite, charcoal forms minute irregularly shaped granules that reflect light in different directions. As a result, the surface appears as a flat black, rather than glossy (like graphite). This is ideal for achieving very dark values and shadows.

Most artists build up quite diverse collections of drawing and painting materials over time, without ever using most of them. Here is a selection of pencils and charcoal plus the coloured pencils that I use most often.

PENCILS

Graphite pencils are the usual choice for sketching and more detailed drawing. These are graded according to hardness – H meaning hard and B meaning black. HB grade are the middle of the range, while B, 2B, 3B and so on are softer, and H, 2H, 3H and so forth are harder. For general sketching on paper, or for drawing on canvas before painting, I tend to use just one grade of pencil, 2B. If you need sharper details or darker tones in your drawings, then add perhaps a 2H and a 5B to your collection. It goes without saying, as with all the materials used in this book, that buying just those that you need will save you money.

Carbon pencils

Carbon pencils are traditionally made from lampblack, a form of residual compressed soot created from burning oil. Because they are non-reflective, carbon pencils give much darker values than a graphite pencil, and can be used in conjunction with graphite.

Coloured pencils

Coloured pencils are made from a mixture of pigment, china clay and wax; the amount of clay determines the hardness of the coloured 'lead'. Coloured pencils can be used as an art form in themselves, and can create a high degree of realism. I use coloured pencils mostly for sketches where I need some added colour, or for testing colour schemes for watercolour and acrylic paintings.

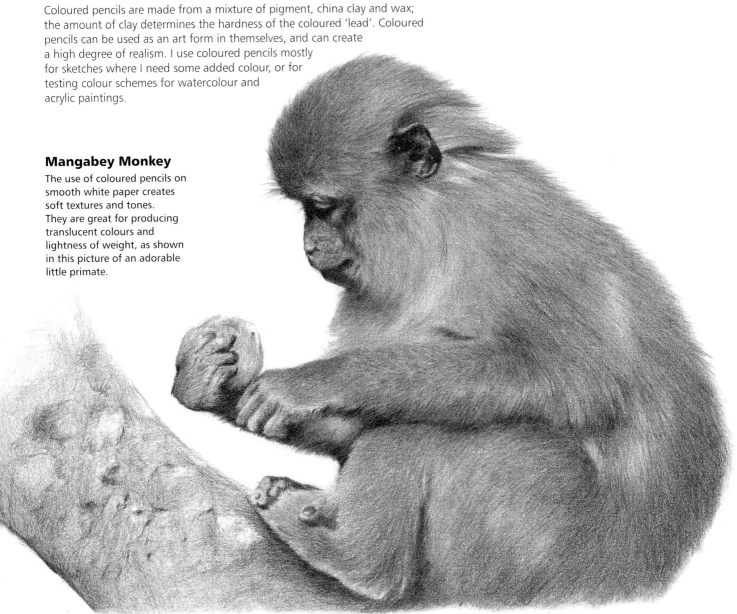

Mangabey Monkey

The use of coloured pencils on smooth white paper creates soft textures and tones. They are great for producing translucent colours and lightness of weight, as shown in this picture of an adorable little primate.

Watercolours

WATERCOLOUR PAINTS

Watercolour paints are pigments held together with a binding agent, and are either presented in tins – pan paints – which are easy to transport for painting on location, or in tubes, which contain additives, such as glycerine, to allow the paint to be squeezed on to and mixed in a palette. As the water that the paint is diluted with dries, it allows the support, usually paper, to show through, giving a translucent look to the painting.

Watercolours can be used with coloured pencils, which will allow you to achieve stronger tonal values (see Bongos on page 5 for a good example of this combined media approach).

Although in can be difficult to create deep, rich fur textures with watercolours, they can be used very effectively when painting animals with very short or no fur.

Personally, I use watercolours mostly for preliminary sketches for larger paintings; but often I do end up 'polishing' the sketch into a complete watercolour study, as in the black leopard opposite.

A selection of watercolour paints in tubes.

Black Leopard

Although this began as a study for a larger acrylic painting, I thought the subtle colour and tones of the watercolour medium provided such a fantastic atmosphere that I was inspired to complete the painting.

PASTELS

Pastels are usually made by mixing pure powdered paint pigment with water and a binding agent, such as gum arabic, into a paste before rolling or pressing into sticks and allowing it to dry.

Soft pastels have more pigment and less binder than hard pastels, which means they have more vibrant colours than hard pastels. The advantage of hard pastels for the wildlife artist is that greater detail can be achieved than with soft pastels alone.

Soft pastels (cylinders) and hard pastels (cuboid).

Pastels and acrylics

Acrylic paints fresh from the tube.

ACRYLIC PAINTS

When I first discovered acrylic paint, it used to be known as 'plastic paint', and I wrongly assumed in those days that it was a totally new synthetic paint. Acrylic is, of course, paint pigment suspended in a polymer emulsion, as opposed to oil (as in oil paints) or glycerine. This gives the paint a more flexible, permanent surface when it dries; unlike oil paint, which can crack easily over time. Acrylic paint is said to be more permanent than other media, with colours being resistant to fading or yellowing.

Acrylic paint is very popular among wildlife artists nowadays for several reasons. Acrylics can be thinned with water to increase flow and create very fine details, or can be used directly from the tube to create thicker and even impasto textures. Traditional glazing techniques can also be achieved with acrylics.

Acrylics do dry quickly, but there are mediums available to slow down the drying time if needed. Acrylic paint can be used on virtually any surface that is neither too greasy nor too glossy. Paper, wood, canvas and leather are just a few examples. Note that very porous surfaces should be first primed with two or three coats of gesso.

North American Red Fox

I think that pastels and velour are the perfect combination for conveying the soft, rich autumn colours in this painting. The background has been 'blurred out' with soft pastels to add more strength to the fox, which otherwise might not be sufficiently emphasised in the painting.

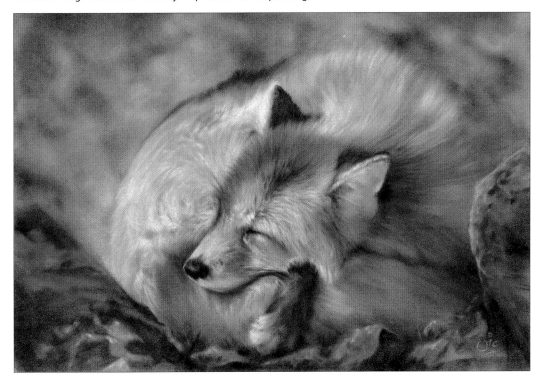

Snow Leopard

The snow leopard's natural habitat is mountainous and often desolate. Using muted greys and browns as a background to this acrylic portrait helps to create the feeling of desolation.

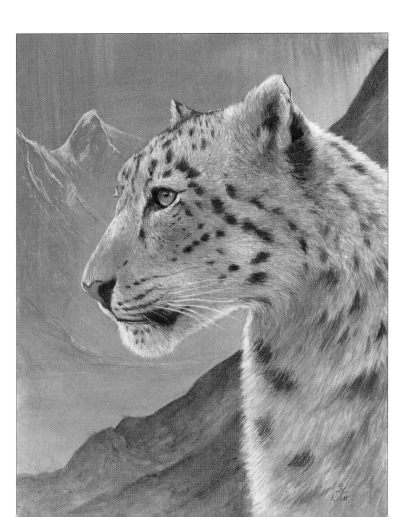

Surfaces

WATERCOLOUR PAPER

If you are new to watercolours, the choice of papers can be confusing. Basically, there are three types of paper texture available: rough; hot pressed (HP), which has a smooth surface, ideal for detailed work; and cold pressed (also known as Not, as in 'not hot pressed'), which has a slight texture, and is suitable for most projects.

Watercolour papers come in varying thicknesses, indicated by the weight of the paper, shown in grams per square metre or pounds per ream, e.g. 300gsm (140lb).

If you are using very wet washes in your painting, it is advisable to stretch the paper first to prevent buckling, or cockling as it is known. When I am painting animals in watercolour, I tend to use the paint in a stronger, less watery, consistency, so I do not have to pre-stretch the paper. It is important to use acid-free papers to prevent yellowing of the painting and, eventually, deterioration of the paper.

Sheets of 300gsm (140lb) slightly textured (Not) watercolour paper; my preferred weight and texture. When choosing a support to work on, try to take into account the textures of the animal you will be drawing or painting. The slightly knobbly surface of this paper really helps to portray the similar textures in the skin of the hippopotamus without having to work too hard with the brush. See the full version on page 89.

A sheet of slightly textured acrylic paper. Acrylic papers are ideal for building up many layers of thicker paint that would be difficult on less substantial supports. The acrylic sketch of the rhinoceros on page 86 uses thicker paint over the initial sketch to create the texture of the thick hide.

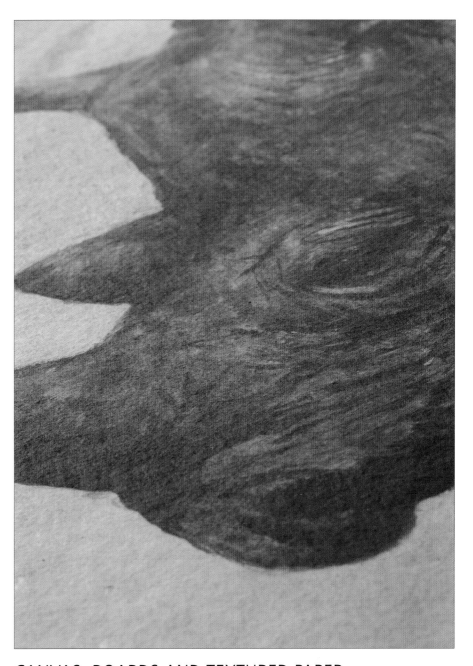

CANVAS, BOARDS AND TEXTURED PAPER

Traditional stretched canvases, canvas boards and textured heavyweight papers are all perfectly suited to the acrylic artist, and I use all of these supports in my work.

For those who prefer to paint fine details and therefore require a smoother surface to work on, untempered (without oils added) hardboard, or 'masonite' is very popular, especially among wildlife artists; the board should be primed with two or three coats of gesso prior to painting to reduce absorbancy, however.

Hardboard tends to be more rigid than other supports, and is therefore particularly suitable for larger paintings.

PASTEL PAPER

Laid paper Often referred to as Mi Teintes or Ingres paper, this is the support with which most people are familiar. The pulp is pressed using a very fine wire mesh, which leaves fine grid lines in the paper. I use this paper mostly for sketching with hard pastels. You can produce complete paintings on this paper, but you will be restricted to the number of pastel layers. In addition, you need to be very careful when using laid paper that you do not smudge your sketch or painting. Using a fixative spray will give you additional 'tooth' to hold a little more pigment, but will also dull your colours.

Sanded Sanded papers hold pastel better than laid papers; there are also cork impregnated papers that perform in a similar way. I find these papers ideal for laying down several layers of rich colour with soft pastels, but they can be difficult to draw fine lines and details on.

Velour Velour is paper covered with a layer of fibres, producing a velvety surface. It is my usual choice for pastel paintings for several reasons. The fibres create a 'pile' like a fine rug, which is capable of holding many layers of pastel (especially harder pastels) without smudging. This is very useful for creating transparent 'glazes' of pastel over a tonal sketch, which gives greater depth to your work. Fine details using hard pastels are also easier on this surface. If the pastels are rubbed well into the surface as you work, there is no need to fix the finished piece.

A sheet of velour pastel paper. Here you can see the soft, velvety texture of velour paper, which automatically gives a soft look to your animal fur, without having to work too hard. See the full gorilla portrait on page 99.

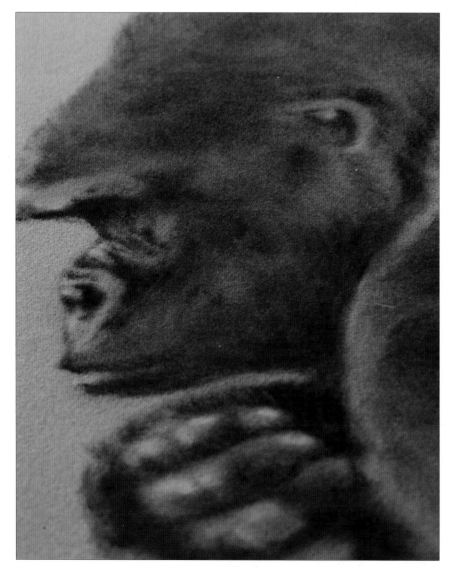

A sheet of smooth black drawing paper. Drawing paper is available in a wide range of colours, which makes this a very versatile surface. See the zebra project on pages 58–63.

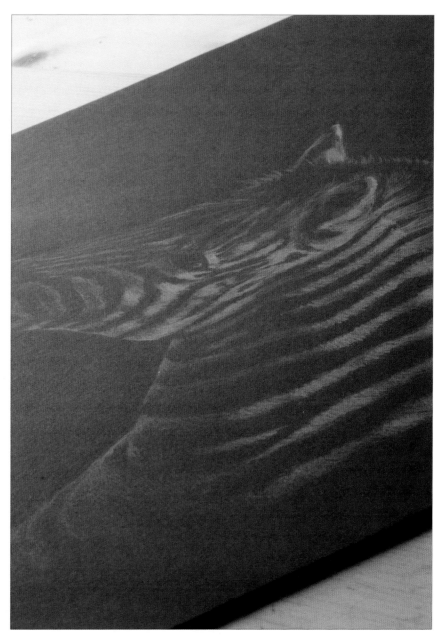

SMOOTH DRAWING PAPER

Smooth drawing paper is a must if you want fine detail in your coloured pencil drawings. Varying the tone of the paper, from black through to white will significantly change the atmosphere of your drawing. Experimenting with different papers can be a lot of fun.

Brushes

Like most art materials, the array of brushes available can be overwhelming, and often bewildering if you are new to painting. One thing to remember is that natural (animal) hair brushes are more expensive than synthetic; so buy what you can afford. For me, the hand that controls the brush is more important.

Softer brushes are generally better for use with watercolours, whereas bristle brushes are more suited to acrylics; but they are interchangeable. I use a variety of synthetic and natural brushes, with a selection of large flat brushes for painting large areas, and smaller (down to size 0), round brushes for painting details.

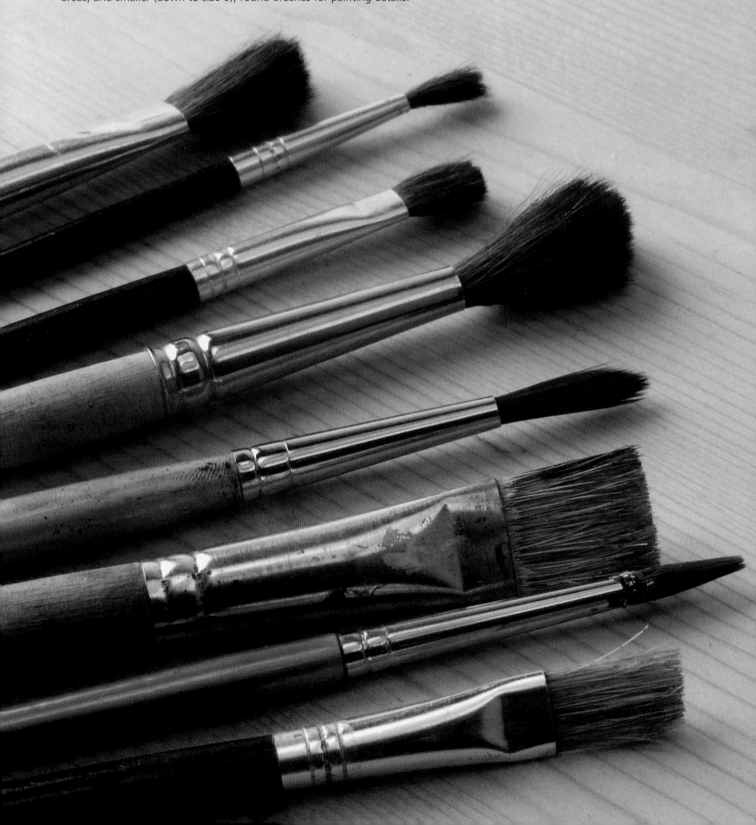

Other materials

Easel A good, strong easel is essential. I use an aluminium tube easel for working while standing. This folds away neatly and is also ideal for the travelling artist. A table top easel is perfect for smaller work, usually with the added benefit of storage for paints, pencils and pastels.

Masking tape A 'low-tack' masking tape is best. As well as adhering your paper to your board, this can also be used to mask off large areas of your painting, especially when using watercolours.

Masking fluid and **old brush** Masking fluid should be used for masking off smaller areas for detailed work. I prefer to use tinted masking fluid which makes it easier to see when applying and removing it. Use an old brush so as not to damage your painting brushes.

Drawing board A good, smooth board for your drawing and pastel papers. I find MDF is perfect, as there is no grain which could be picked up in your drawing.

Eraser Putty erasers are soft and pliable, and are useful for lifting out pastel from surfaces such as velour, sanded papers and the like. I also use a plastic eraser for erasing graphite and coloured pencil from smoother papers.

Sanding block Sanding blocks are small, hand-held blocks with tear-off sheets of sandpaper attached. I use these to 'square off' the ends of my hard pastels in order to keep them sharp for detailed work.

Kitchen paper In addition to helping mop up spillages, kitchen paper is very useful for other tasks. Scrunched up, kitchen paper can make an effective blender for pastels, and for scrubbing large areas of acrylic paint – very useful to create background texture.

Toothbrush Do not throw your old toothbrushes away; they are ideal for creating spattered paint effects – just be aware of what or who is behind your painting at the time!

Pencil sharpener Always have a pencil sharpener to hand when using pencils and coloured pencils; working with blunt points will affect the quality of your work.

Water pot An old glass jar is ideal to store clean water for rinsing your brushes. I recommend one with a broad base – these will not get easily knocked over when the cat jumps up to see what you are up to!

Tortillon or **blending stump** Ideal for more controlled blending with charcoal, pencils or pastels, these are very tight rolls of paper, coming to a fine point.

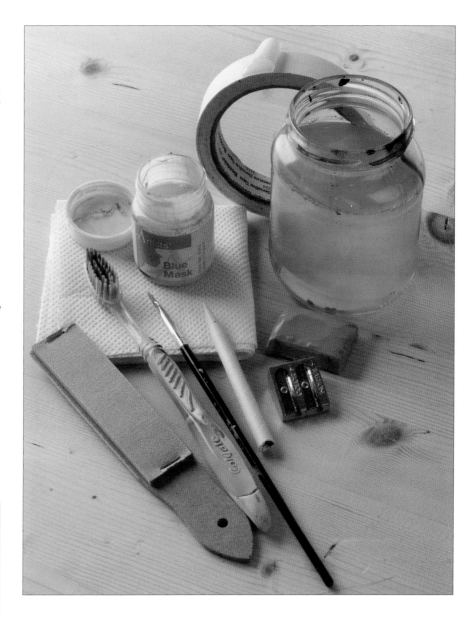

Vic's tip

Do not leave masking fluid on the surface for too long. Aim to apply and remove it within two hours at most.

Impact: tone and colour

For me, possibly the most important part of a painting or drawing is tone. Tone is the amount of light or dark in your painting; from extremes of black in one area, through to pure white in another. A wide range of tonal values can give your artwork great depth and strength. Strong tonal values can also add drama and atmosphere.

Tone

In terms of colour, tone is simply how dark or light a particular colour is. Some colours, such as yellow, naturally give lighter tones than brown, for example. But even this is relative to the adjacent objects, background or the overall colour scheme of the picture. You can see what I mean when you look at the two drawings of the Amur leopard, the world's most endangered big cat, on this page, which I have drawn with the same coloured pencil on different coloured paper.

Coloured pencil drawings are not necessarily associated with strong tones, especially on a traditional white drawing paper (see the top drawing), but they can give you quite a textured drawing with some depth. Look what happens, however, when you use the same medium and the same colours on black paper (bottom). The very darkest tone in the drawing, black, is already established, producing a dark, atmospheric setting which would be quite difficult to achieve with a black coloured pencil on white paper, not to mention expensive. Imagine how many layers you would need to produce such a dark tone; even then, the black would not look as intense, because of the waxy sheen of coloured pencils.

TONE: BLACK ON WHITE

Charcoal is a very useful drawing and sketching medium. It can be moved around on the surface to produce midtone greys or lifted out with an eraser to create highlights. It can be difficult to get any kind of detail, however, and is prone to smudging.

If you want rich, dark tones in your drawings and sketches, then try a combination of charcoal for basic tones and a carbon pencil for very dark tones and detail.

Vic's tip

Check tonal values by squinting at your drawing or painting. This will blur out detail and allow you to see if your dark and light tones need adjusting.

1 Start by covering the paper with a layer of charcoal, rubbing it in with a piece of paper towel. You may need to repeat this process three or four times to achieve the correct tonal value approximating the midtones in the racoon fur. Then sketch in your outline with a B grade carbon pencil.

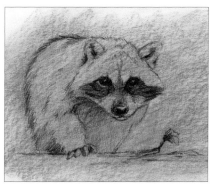

2 Sketch in the darker fur tones with the same carbon pencil, followed by the details such as eyes, ears, nose, claws and tree bark details. You will now have the dark and midtone values established.

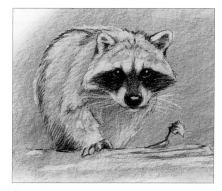

3 The final stage is always fun to do. Take a hard plastic eraser and use the corners and edges to lift out the lightest fur tones and highlights. For the small reflections in the raccoon's black eyes, cut off a small wedge of the eraser with a sharp knife and lift out the charcoal with a corner.

TONE: WHITE ON BLACK

Possibly one of the easiest ways to deal with animals with a lot of black fur is to use a black support. The Colobus monkey's coat is black and white. You could, of course, draw the animal on a white background, thus concentrating on establishing all of your dark tones with a combination of charcoal and carbon pencil, as in the raccoon sketch. Alternatively, you could save yourself a lot of time and effort, and, with a single white pencil, concentrate instead on the white fur and highlights. This can produce a drawing with a lot of atmosphere.

1 Sketch in your simple outline and basic shapes with a white coloured pencil. Try to keep the sketch quite light at this stage – remember that you may want to erase some of these lines later on.

2 Now begin to establish the lighter areas of the drawing. Do not go for the full on white yet, but concentrate on creating a soft, almost translucent midtone grey. At this stage, you can use a hard plastic eraser to tidy up the drawing if you do not want your sketch lines to show.

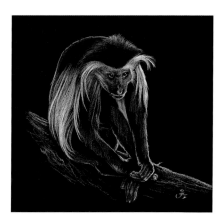

3 Time now to sharpen your white pencil and go for the fine details. Draw in those silky white hairs in the monkey's mane, highlights around his mouth and nose, and of course a little twinkle in his eyes. Think about a light source as well, and draw extra highlights on the side where the light is coming from; in this case top right.

Colour

LIMITED COLOUR: USING THE SURFACE

Using limited colour on a toned surface is a classical approach to drawing. This technique allows you to achieve subtle tonal values, with the added benefit of being able to introduce stronger highlights, which is not easy to do on a white surface.

Classical artists, such as Da Vinci and Raphael, among others, used sanguine (red-brown) Conté crayons and white chalk on a sepia-toned support to produce wonderful sketches and drawings in which the sanguine crayon is the darkest tone. The end result is much warmer and softer than traditional charcoal or pencil drawings. Let's see how it works with an animal subject, more specifically a mountain lion (owing to its extensive habitat range in the Americas, it is known by a great variety of names including cougar, puma and catamount).

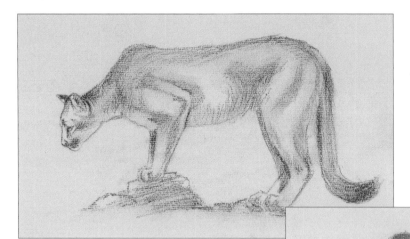

1 Sketch in the basic outline of the mountain lion using a sanguine Conté crayon on sand-coloured pastel paper. Roughly establish the shadow areas at this stage, and try to get a reasonable dark tone around the powerful muscles of this gorgeous cat.

2 Using only a tortillon (paper blender), drag the sanguine colour into surrounding areas. Where you have no colour from step 1, the tortillon will pick up just enough to tint the paper for lighter coloured fur. Use the pointed tip to carefully blend and shape in more detailed areas, such as the ears, eyes and mouth.

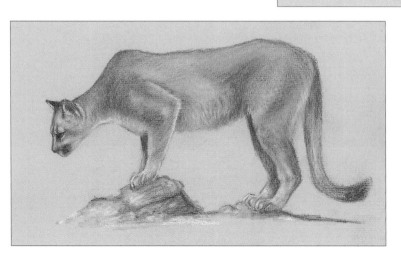

3 Create highlights in the sketch with a white Conté crayon, leaving them sharply rendered in the head and other areas with little fur, including the rocks. Blend the highlights back a little with the tortillon in softer areas with more fur.

LIMITED COLOUR: APPLYING COLOUR

A lot can be achieved by restricting your palette when painting. It can sometimes be confusing, if not a little daunting, when we see the array of colours presented in tubes in our local art shop. What colours should I buy? Which shades? Burnt sienna or burnt umber? Cobalt blue or Prussian blue? In my opinion, you can not go far wrong when painting animals if you have a warm brown (burnt sienna) and a cool blue (Prussian blue). These two colours form the basis of warm fur and cool shadows. With the addition of one more colour to represent the overall appearance of your animal and white for highlights, you will be amazed at what you can do. Let's see how we can paint a polar bear in a cold environment using two warm colours and one cool colour.

1 Using a size 16 flat brush, prime the acrylic paper with a coat of burnt sienna. This will give the painting tonal depth. Then add a semi-transparent layer of Prussian blue when the first coat is dry. The Prussian blue will serve as the tone of the sky and ice as well as giving you cool shadow tones in the polar bear. Finally, sketch in the bear and the ice shapes using a B grade carbon pencil, so you will be able to pick out details such as fur texture through subsequent layers.

2 Now, with a mix of yellow ochre and white, a little thicker than the Prussian blue, paint in the fur that is in direct sunlight, using a 7mm (¼in) long flat brush. This is the principal colour of the polar bear. Do not try to paint too much detail at this stage.

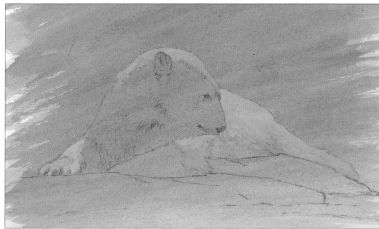

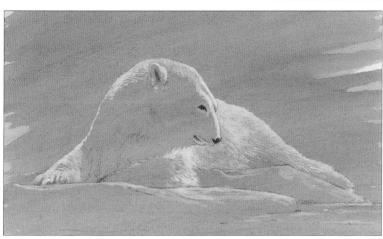

3 Use a size 2 round brush for the final highlights and details. Paint in the highlights of the yellowish fur, adding some fur texture here and there. The paint should be a little thicker than the previous layer. You can also put in some reflections in the ice. If you need to add in some darker detail, the eye and mouth for example, use the Prussian blue. Avoid black for these details, otherwise they will appear too strong against the other tones.

Getting started

Early examples of wildlife art that date back more than 30,000 years, have been discovered in caves like those in Lascaux, France. Cave painters did not have live models in the caves to pose for them, yet they produced wonderful, anatomically correct paintings of the animals they saw and hunted, by observing them from life, possibly on a daily basis. In this, we are just like those artists: whatever your source of reference might be, observation is paramount.

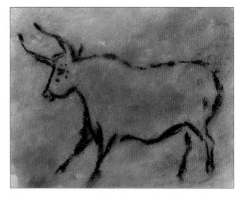

This piece, executed in charcoal and pastel on sandpaper, is styled after ancient cave paintings. The precision and animation of these ancient artworks makes them arresting even today.

Finding and using reference

USING PHOTOGRAPHS

Of course, reference photographs are extremely useful to the animal artist; they can help you with markings, fur colour, posture, and so on. However, be careful not to rely on photographic material too much. Digital photographs printed on standard printers can easily give you incorrect colours and extreme tonal values, as well as other misinformation, such as foreshortening your subject, for example.

SKETCHING FROM LIFE

Zoos and wildlife sanctuaries are great places to sketch non-domestic animals. It is all too easy in this digital age to walk around a zoo and just take dozens of photographs to use as reference material at a later stage. Try taking a small sketchbook and pencil next time you go. Even if you only manage to sketch the simplest shape of a detail – an ear, a paw, an eye – you will find yourself observing the animals, and valuable information will be stored in your brain.

SKETCHBOOKS

I always keep a sketchbook to hand, whether for making quick sketches of the various cats and dogs we have, or for sketching ideas and compositions for paintings. They can be very useful memory aids, as well as fun to look back on. Sketchbooks are a great place to experiment with different compositions, and for combining your field sketches with your photographs and other reference material before you start on your next painting.

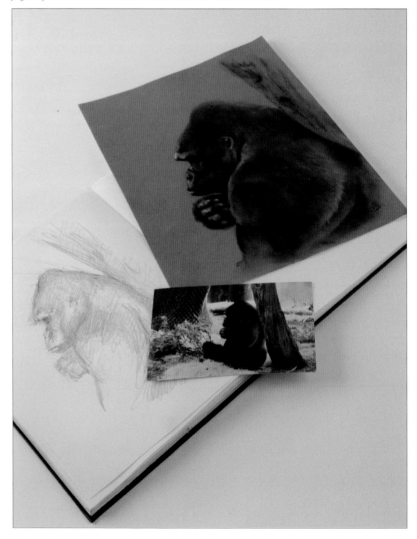

Clockwise from lower right: photograph of a gorilla in situ, a sketch made on the spot, and the finished piece. A larger image, and instructions on how to recreate the finished picture, can be found on pages 98–99.

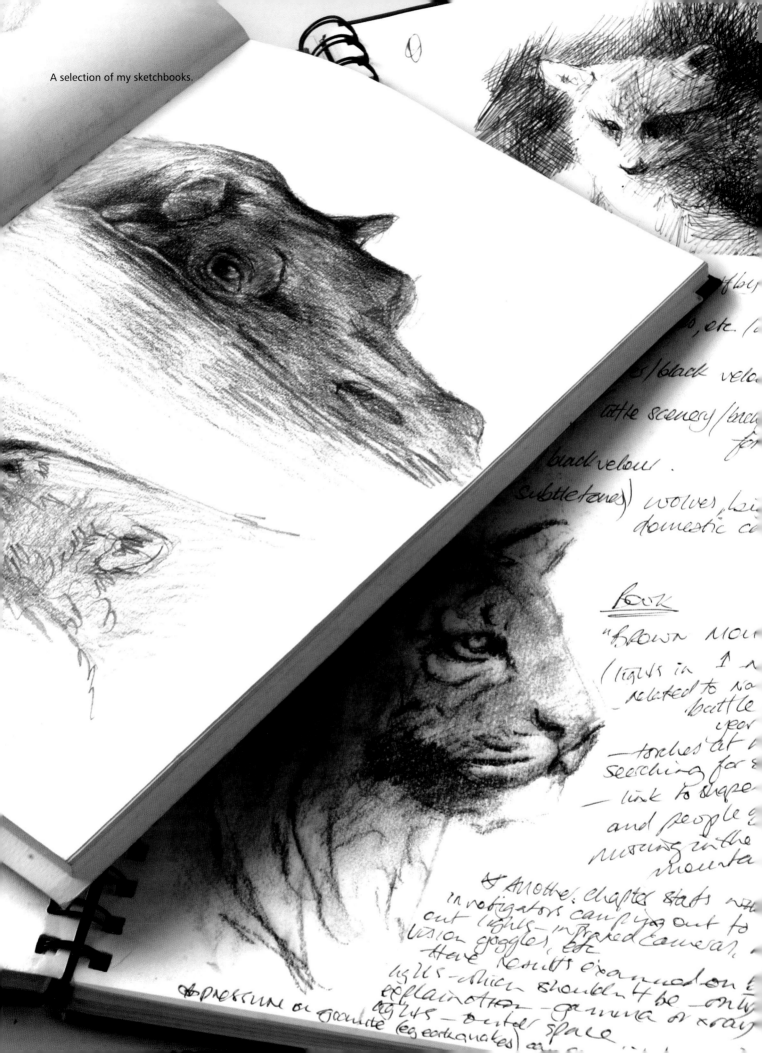

A selection of my sketchbooks.

First sketches

SIMPLE SHAPES

The French impressionist painter Paul Cézanne once put forward a theory that everything in nature can be simplified to basic geometric shapes: a cylinder for a tree trunk, a sphere for an apple, and so on.

In a way, this is how we see things as a child. Simple shapes form the basis of our view of the world around us, and this is reflected in the pictures that we draw and paint as children. We are able to draw and paint animals from memory at an early age – albeit using simple shapes, but, as with early cave paintings, this is primarily done from remembered observation, rather than copying from photographs, or from life.

As animal artists, we can use these notions to achieve correct shapes and proportions when drawing animals freehand – a circle for a head, ovals for parts of the body, triangles for ears and cylinders for legs. Below is a basic construction of a tiger's body using the geometric shapes described above.

Basic shapes take only a few seconds to construct, and just a few seconds more to make proportional corrections. For example, if the head appears too big, simply draw a smaller circle.

This drawing may be childlike, but because simple shapes are so powerful, it is clear what it is intended to be!

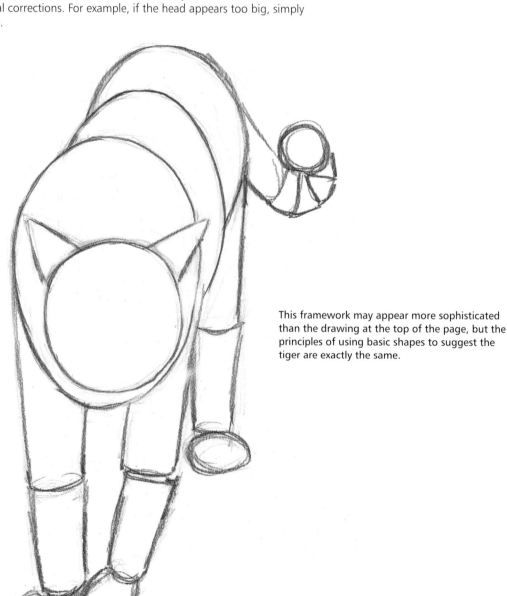

This framework may appear more sophisticated than the drawing at the top of the page, but the principles of using basic shapes to suggest the tiger are exactly the same.

MORE COMPLEX SHAPES

If we want to continue this approach in order to construct more accurate anatomical drawings, we simply need to employ more geometric shapes. Let's use the tiger's head from the picture opposite as an example.

In the picture to the right, notice how I have divided the circle in half horizontally and vertically to give the eyeline, and to centre the nose (which is tilted slightly in this case). The ears are formed using simple triangles, which can be rounded off later. The eyes are small circles, so it is easier to draw them the same size and line them up correctly. Finally, the nose and muzzle are added with a triangle and ovals demarcate the cheeks and chin.

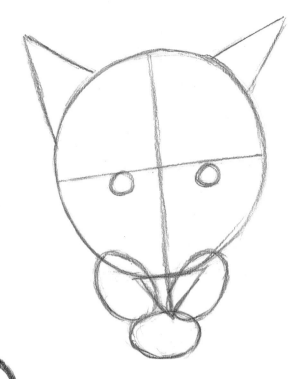

THE SPINE LINE

Now let's construct the whole tiger with those shapes mentioned above. I find it useful to add a 'spine line' at this stage. This line is drawn from the tip of the nose to the tip of the tail, following the contours of the geometric shapes beneath. At this point, the tiger begins to look a little more realistic, and proportions can be easily checked against your reference. The whole process is much quicker than drawing the outline as you see it, then having to erase mistakes, redraw, erase again and so on.

Developing your sketches
ADDING SIMPLE DETAILS

Once you are happy with the proportions of your basic shapes, you can begin to round off the shapes and create a more natural looking outline. At the same time, add in a few details such as eyes, nose, markings and the beginnings of fur texture, as in the tiger example below. The sketch will now be ready to transfer on to whatever support you are going to use.

The developed sketch retains the suggestion of the spine line, but the geometrical shapes (see previous page) are developed into more realistic muscle and fur textures that will be useful for the next stage.

This picture shows the geometrical shapes overlaid on top of the coloured pencil sketch opposite. Note how the two sketches match up.

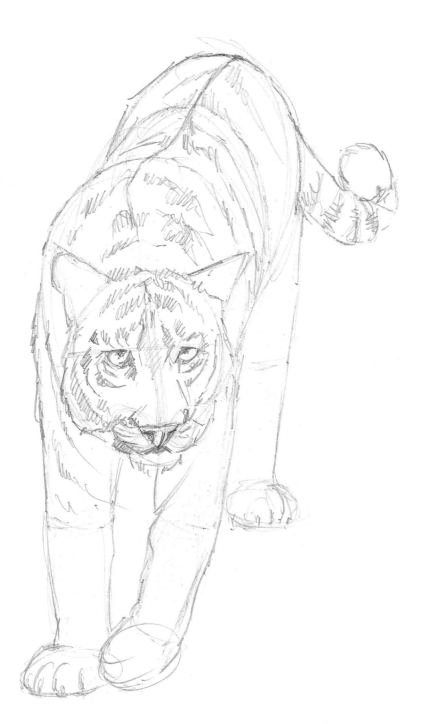

Opposite
The finished picture.
The sketch was transferred on to black drawing paper, using white transfer paper. I then used coloured pencils to develop the tiger, which might serve as a tone and colour sketch for a more complete painting at some point.

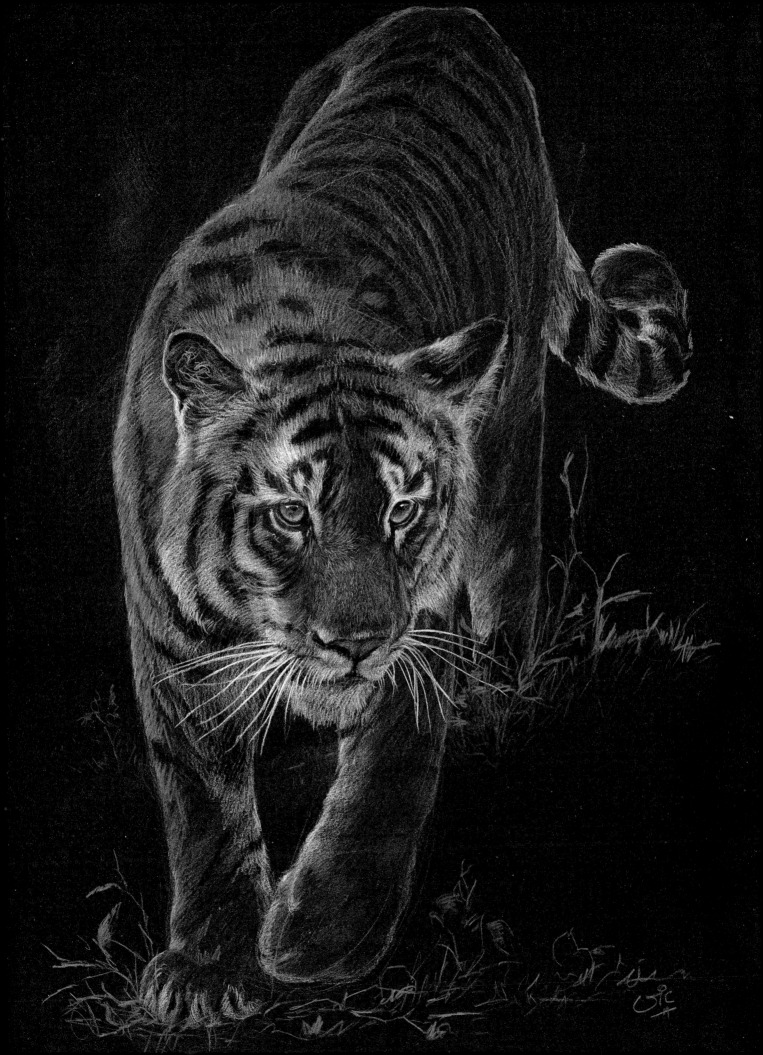

Composition

Composition means 'putting together', as in an arrangement of musical notes to create a symphony, for example. In the case of art, composition is the arrangement or placement of elements within a painting to create something which is visually appealing.

There is an enormous amount of information available about compositional techniques in art, and I do not propose to go into the subject in great depth in this book. Composition in a painting can be subjective. As with a musical composition, it is impossible to please everyone, and there will always be debate about what makes a good picture. There are, however, certain tried and tested compositional techniques which are worth knowing about, and will certainly help you with your wildlife painting, whether used individually or in combination.

CREATING AN ENVIRONMENT: BACKGROUNDS

Let's have a look at how we can create different compositions from the same source photograph. I want to paint one of my favourite cats, a mountain lion, high up in a vast mountain landscape. I am using two reference photographs for this painting; the mountain lion from a conservancy, and a background, somewhere in California.

It is reasonable to assume that in the majority of wildlife paintings, the most important element will be the subject; and if the subject is to be the main focus of the painting, then why not place it where it is most visible, right in the centre of the picture?

You can of course do exactly that, as in the placement of the mountain lion in the example to the right. The problem is, while your attention is drawn to the subject in this composition, there is not much visual flow to take the viewer into and around the lovely background that you spent so long painting. Also, this composition does not show the vastness of the mountain landscape. What we need is something to bring the eye back into the picture.

In the second example (below left) I have introduced a tree on top of the rock, something that appears in my original reference photograph of the mountain landscape. This does serve as a visual 'stop sign', but I'm still not sure that it belongs in my composition as I have now lost the feeling of space and being up high in the mountains that I wanted to create.

A useful way of creating a sense of space in a landscape is to give your painting a panoramic aspect, either horizontally or vertically, which is, incidentally, a great way to convey height, either of mountains or trees. This is what I have done in the third example (below right). The distant horizon line is roughly a third up from the bottom, which, together with the panoramic aspect, lets us see the vastness of the sky as well as a sense of being high up with the lion.

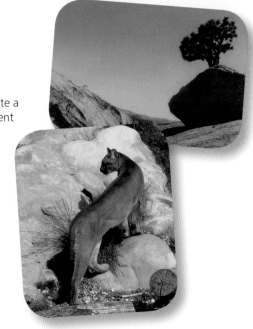
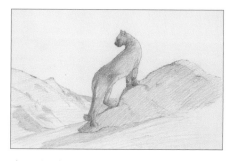

The source photographs.

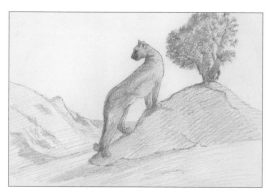

The animal's pose creates a naturally occurring diagonal, a classic way of leading the viewer into the painting. The problem here is that the eye is led straight across the picture from the bottom left and off at the top right.

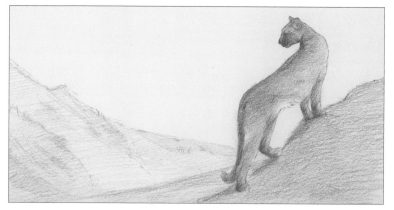

The tree in this example competes with the mountain lion to be the focal point, and its addition seems to tighten up the whole composition, losing the sense of space.

As well as increasing the width of the painting in proportion to its height, I have made another significant compositional change. Instead of using the tree as a visual stop, I have moved the mountain lion over to the right of the painting; now following a classic compositional guide, 'the rule of thirds', which sections the paper or canvas into thirds horizontally and vertically.

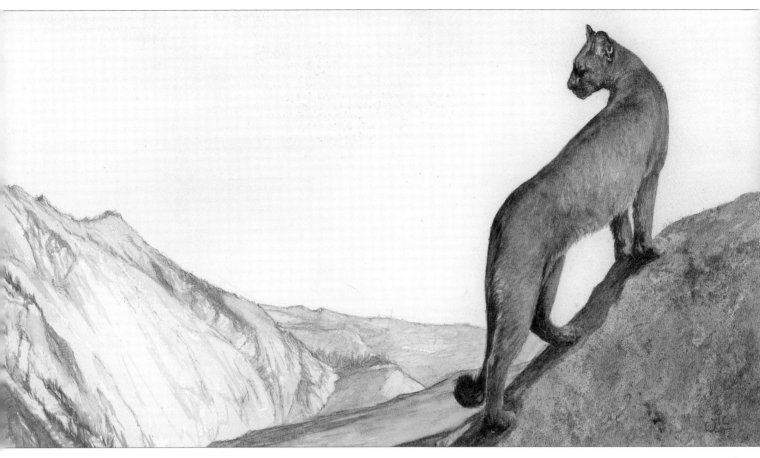

Mountain Retreat

Based on the third example opposite, the mountain lion now provides her own visual stop. The eye is led into the painting on the slope in the foreground, travels up the lion's body, turning with her head to look back at the distant mountains, which themselves are angled back down towards the foreground slope, completing the loop. Rendered in watercolour, this painting measures 38 x 20.5cm (15 x 8in).

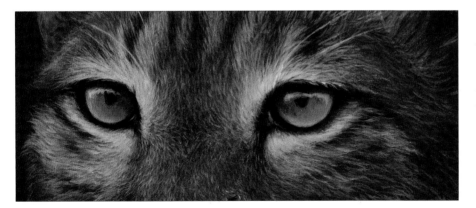

Lynx Eyes

Another example of a dramatic image in a panoramic format, this picture is worked in acrylics. It measures 21 x 9cm (8¼ x 3½in).

CROPPING

The advent of digital photography has made it easier for the wildlife artist to visualise and experiment with compositions – and I am all for making life easier.

One aspect of digital photography software that I particularly like is the ability to crop my photographs, not only to rid the image of unnecessary clutter, but also to zoom in on a subject and focus on those elements that I want to portray in a drawing or painting – if an animal has particularly stunning eyes or unusual facial markings, for example. This is also a great way to draw the viewer in and get 'up close and personal' with your subject.

Big cats

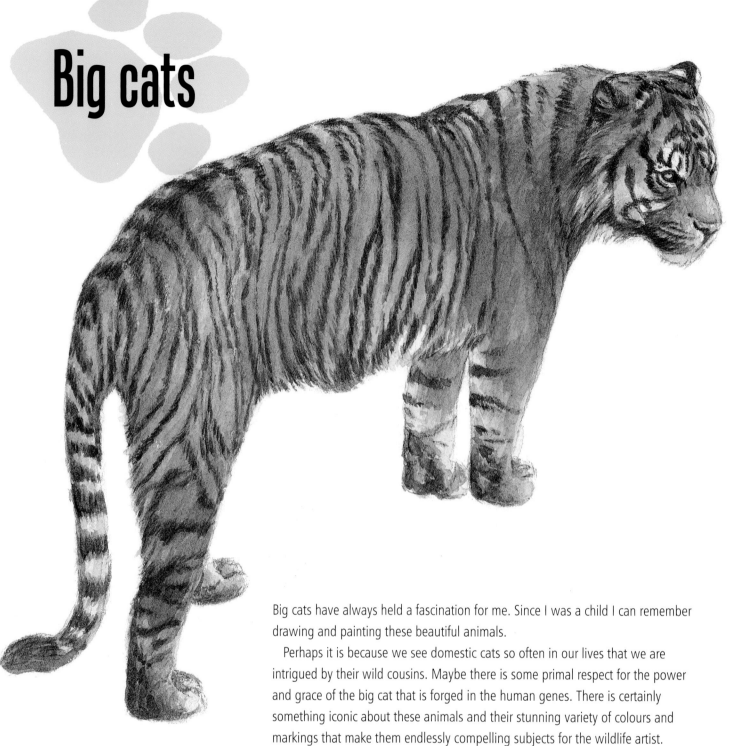

Big cats have always held a fascination for me. Since I was a child I can remember drawing and painting these beautiful animals.

Perhaps it is because we see domestic cats so often in our lives that we are intrigued by their wild cousins. Maybe there is some primal respect for the power and grace of the big cat that is forged in the human genes. There is certainly something iconic about these animals and their stunning variety of colours and markings that make them endlessly compelling subjects for the wildlife artist.

The term 'big cat' generally applies to the four larger species of the genus *panthera*: tiger, lion, leopard and jaguar. However, smaller species, such as cheetah, snow leopard and mountain lion are also usually known as 'big cats', so I will use the term to cover all of the above.

All cats, including domestic cats, are carnivores, and most are similar anatomically and behaviourally. Cats are efficient predators; their eyes, intense and forward facing, are the very essence of a supreme hunter.

Basic shapes

Cats of all types, large and small, walk with attitude, as though they are constantly on the prowl, ready to pounce on the smallest movement. Because of this, the head is usually carried low, which means that you see quite a lot of the shoulders.

Vic's tip

Drawing geometric shapes is not as easy as it first seems. Practise drawing circles and egg shapes on their own, before connecting them in different arrangements to create various poses.

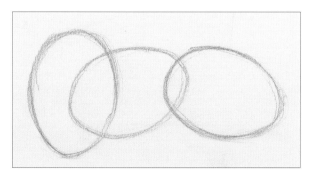

1 In a freehand drawing, the body can easily be constructed using three egg shapes, one behind the other at various angles.

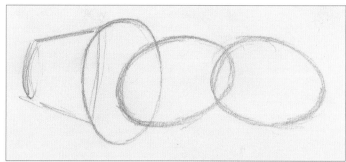

2 Add a cylinder shape to represent the neck.

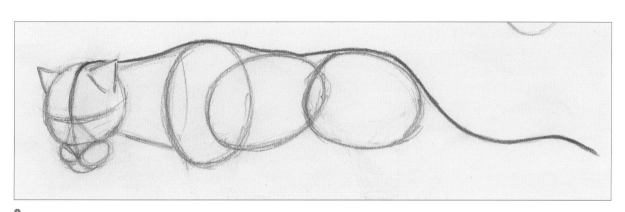

3 You can now position the head and draw a line from the head to the tip of the tail, following the curves created by the underlying shapes. This will create a 'spine line' (see page 27), and show you the first real shape of your big cat.

With the principles explained above, it is relatively simple to build up the basic shapes for a cat in any pose. The example to the right shows the basic shapes for the tiger on the opposite page.

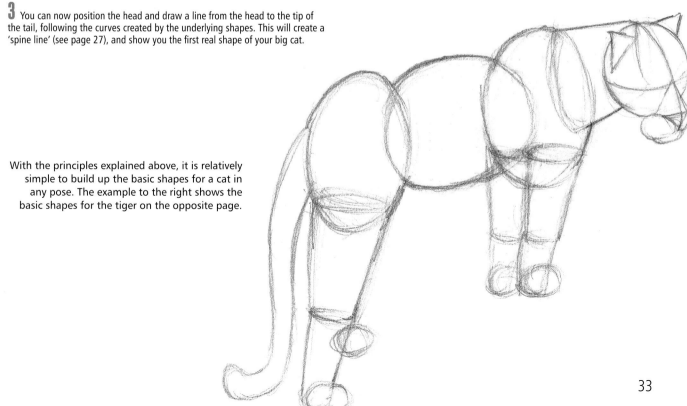

Distinctive features

EYES

Cats' eyes have the ability to appear at once serene and menacing. The ability to capture these expressions when drawing or painting the eyes of a big cat will really heighten the impact of your work.

I often refer to the markings around the eyes of tigers, leopards and other big cats as 'make-up'. Even cats with few or no other markings have dark rims and tear ducts.

Most big cats have round pupils, unlike domestic cats, which have slits. The pupil dilates to almost completely fill the iris at night, enabling them to see very well in the dark. In bright light, the pupil contracts to a small round dot.

Big cats' eyes vary in colour from yellow to amber and shades of green. The external light source creates highlights and reflections in the eyes, making them look shiny, just like coloured glass marbles. You can see this interaction in the profile view to the right.

Getting the eyes to look realistic is not as difficult as you might think. We have seen how the cat's eye is constructed, now let's practise drawing it using coloured pencils.

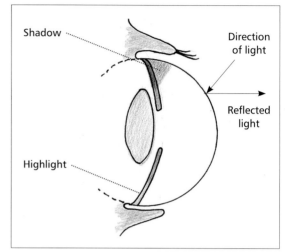

Profile view of a big cat's eye.

1 Think of the eye as a circle representing a sphere: draw a circle to represent the eyeball. Add in the round pupil to the required size (this is dependent on the brightness of your light source). The upper eyelid forms the principal shape of the eye. When hunting, it is lowered, almost horizontally, shielding the eye from the sun and giving the characteristic predatory look. Draw this line in just above the pupil. Draw a more rounded line for the almost almond-shaped lower rim. Note the addition of the third eyelid and tear duct in the corner of the eye.

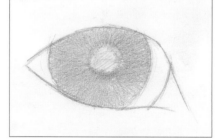

2 Now we can begin to add some colour in the eye. Start with a green coloured pencil and shade in the iris around the pupil. Try to make the marks from the pencil radiate out from the pupil, like a cartwheel, this represents the muscles that open and close around the pupil. In normal daylight, light will come from the sun above the cat, so use a yellow coloured pencil to lighten the iris around the bottom of the eye.

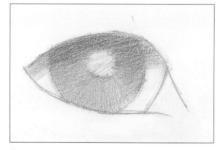

3 The sunlight will cast a shadow under the eyelid, darkening the iris in that area. You can use a black coloured pencil to shade over the green. At the same time, add some shadow at the top of the white of the eye (sclera) and the right-hand corner of the iris, as there will also be some shading there from the side of the nose.

Vic's tip

Keep practising various body parts in isolation – eyes, ears, legs, and other details. You will very soon become proficient at bringing all these elements together, realistically, and with correct proportions.

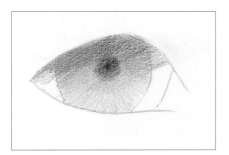

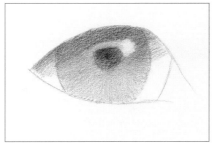

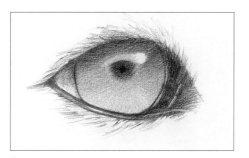

4 Now it is time to draw in the pupil, using the black coloured pencil. Remember that the pupil is only a hard round spot at its smallest point. As you make the pupil larger to let more light in, try to keep the edges a little blurred, as these edges will represent the muscles of the iris opening and closing.

5 The outer layer of the cornea acts as a mirror, reflecting the surroundings. Here, we will draw a simple representation of the sky and sun. Take a hard plastic eraser and rub out a curved line below the shadow and across the pupil. Remember that the eyeball is curved, so the reflection should not be a straight line. You can put a little colour in this reflection with a blue coloured pencil (only if the sky is blue, of course). Then, with the eraser, lift out a spot to represent the sun.

6 Finally, with the black coloured pencil, darken and thicken the rims, third eyelid and tear duct, using the eraser to lift out some highlights. Add in some fur in the surrounding area, and your realistic eye is complete.

Vic's tip

When drawing both eyes face on, it is always easier to begin with two circles rather than trying to draw the external shape. Circles are easier to line up and shape correctly. Uneven eyes will ruin your whole painting.

Clouded Leopard

While most big cats have round pupils, this detail of the picture on the cover shows the unusual eyes of the clouded leopard. This cat species' eyes do not dilate to complete circles like big cats, but nor do they constrict to narrow slits like domestic cats.

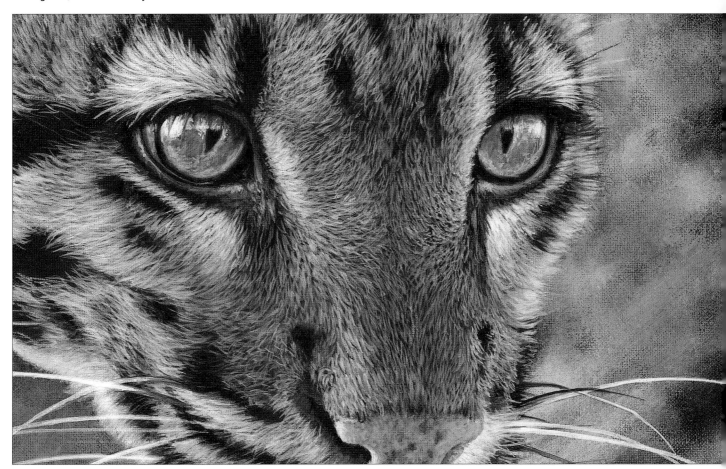

NOSES

The nose of a big cat is a very powerful sensory organ, and together with its eyesight, makes it a very formidable hunter.

The fleshy tip of the nose is called the leather, and it can vary from pink to reddish in colour; and through to black in the case of a cheetah. The leather is cool and moist, and is able to detect changes in temperature, as well as being very sensitive to smells and scents. Some big cats, especially lions, like strong smells such as lavender, rosemary, and even catnip!

Vic's tip

All cats have four rows of between six and eight whiskers on each side of their face. Do not forget to add them in!

1 Draw the basic shape of a cat's nose. This is a triangle when viewed from the front.

2 Draw a vertical line through the centre of the triangle to line up the bottom of the nose with the cleft between the upper lips.

3 Describe a bow-like shape at the top of the nose where the fur begins.

4 Draw in the basic shape of the nostrils.

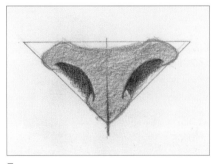

5 Round off the angular structure of the nose to create a more natural shape.

Vic's tip

Straight lines and angles are a useful and simple way of constructing natural shapes.

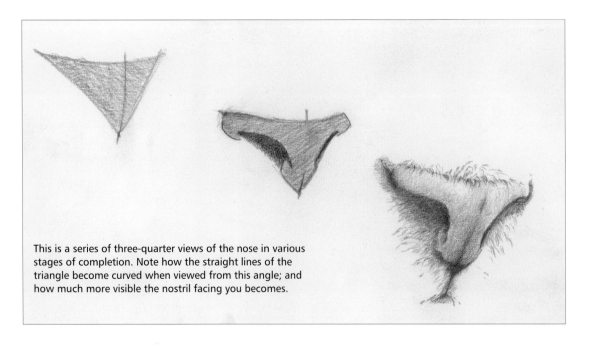

This is a series of three-quarter views of the nose in various stages of completion. Note how the straight lines of the triangle become curved when viewed from this angle; and how much more visible the nostril facing you becomes.

PAWS

Big cats, like domestic cats, have retractable claws, and they are normally sheathed, which helps to keep them sharp. The cheetah, however, has claws which are permanently protracted to provide better grip when sprinting.

Like dogs, cats have five toes on the front paws, including the small dewclaw on the side. The hind paws have four toes. Cats walk on their toes (digitigrade) and are able to place their hind paws in almost exactly the same spot as their front paws, reducing the risk of stepping on noisy twigs, minimising sound and increasing their predatory prowess. This has led to the enduring image of big cats as 'silent hunters'.

Some people find drawing animal paws difficult, and would prefer to leave them buried; either in the undergrowth; or hidden behind rocks in their paintings. I personally find them to be interesting features and easier to draw than human feet. There are bound to be occasions where they will need to be shown, so here are my notes on how to draw cats' paws.

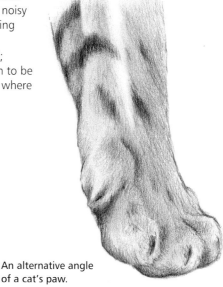

An alternative angle of a cat's paw.

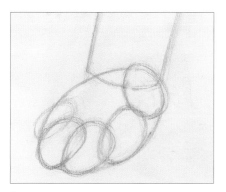

1 When you are drawing the paw, begin with basic shapes. The lower leg is represented by a cylinder. Add the foot as an oval, then draw small ovals for the toes. Note the placement of the toe shapes, one behind the other as they curve away from you.

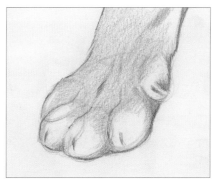

2 Once the placement of the paw and toe shapes are correct, sketch in the outlines and fur texture more precisely. Add small dark lines to indicate the sheathed claws.

FUR MAPS

When drawing or painting close up, as in a portrait, details become visible, and mistakes more apparent. One feature that will let your painting or drawing down if it is rendered incorrectly is the fur, which grows in different directions, particularly on the face and head.

This diagram shows the direction and length of the fur on the head of a typical cat (in this case a lynx) as a series of arrows in both the front and profile views. Observation is the best way to see the 'fur map' of an animal; and, as texture and thickness varies so much, you should try to study fur as closely as you can when visiting a zoo or a sanctuary. If that is not possible, then have a look at your own or your neighbour's cat. (Just watch out for those sharp claws!)

Note the apparent meeting point of the cat's fur between its eyes in the front view. From this point the fur radiates outwards.

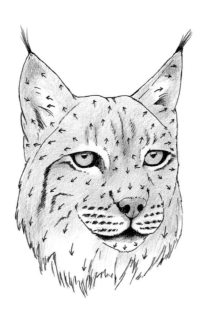

Front view.

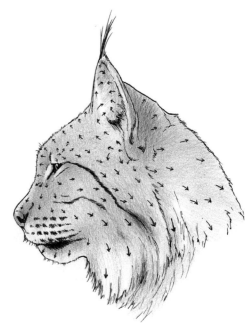

Vic's tip

Drawing and painting fur can be simplified if you remember three things: direction, length, and thickness of fur.

Other big cats

CHEETAH

The word cheetah comes from Hindi, meaning 'spotted one', and that is important to remember. A cheetah's markings are spots, not rosettes like a leopard. The cheetah is the only living member of the family *Acinonyx* which is Greek for 'non-moving claws'. Unlike other cats, the cheetah's claws cannot retract completely, which gives better grip for turning quickly when chasing prey. Over time they become blunted from wear.

The cheetah is also the fastest land mammal, and can accelerate from 0–62mph (0–100kph) in just three seconds, reaching top speeds of 75mph (120kph). This burst of speed is short-lived, as the cheetah is a sprinter, rather than a distance runner. In many ways, the anatomy of a cheetah resembles that of a greyhound more than a typical cat; having a deep chest, narrow waist and long legs with muscular thighs.

Cheetahs have smaller, flatter heads than other big cats, with distinctive black teardrop markings running from the inside corners of their eyes; these help to keep the sun from glaring into their eyes, rather like the black paint on an American footballer's cheeks.

The cheetah's temperament enables it to be tamed quite easily. Cheetahs were often used by ancient Egyptians as a hunting cat. Associating the animals with royalty, and even worshipping them, Ancient Egyptians used black eyeliner (kohl) to make their eyes appear catlike.

Similar and distinguishing features

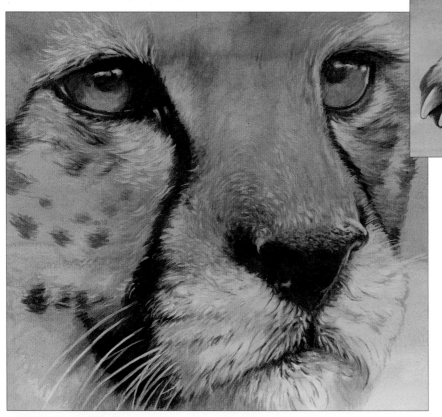

Claws
Note how the cheetah's claws are protracted, even at rest. Although they may look sharp, they blunt quickly, and are no sharper than a dog's claws.

Teardrop markings
Note the shape of the distinctive teardrop, which runs from the cheetah's tear duct, down the side of the nose, and curving around the muzzle, widening as it does so.

Cheetah in acrylics

1 Begin by toning the whole surface with a wash of burnt sienna over a pencil outline of the cheetah – this will give the painting an overall warm tone, as well as sealing the drawing so it does not dirty the final result. Apply the paint with the size 16 flat.

2 Paint the sky using Prussian blue, with a little Payne's gray to give it a stormy feel and a touch of white to lighten it a little.

3 Block out the grassy area with yellow ochre, a touch of titanium white and patches of sap green/yellow ochre mix here and there, allowing the burnt sienna tone to show through in places to suggest red African earth. Save the detailed grasses until the cheetah is finished.

4 Change to the size 8 round brush and use a mix of burnt umber and burnt sienna, diluted to semi-transparency, for painting the shadows in the cheetah's body and the shadow on the ground beneath. A more opaque mix of yellow ochre and white is used for the lighter parts of the body.

5 Add the spots with a size 2 round brush and burnt umber – adding Payne's gray for the spots in shadow, and burnt sienna for those in lighter areas.

6 Add Payne's gray and titanium white for the final touches – eyes and teardrop markings, highlights and whiskers.

7 Add a few individual grasses around the feet and shadow and in the foreground to complete the painting.

The finished picture.

You will need

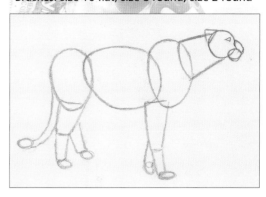

450gsm (210lb) acrylic paper: 32 x 24cm (12½ x 9½in)

Liquid acrylic paints: burnt sienna, Prussian blue, Payne's gray, yellow ochre, titanium white, sap green, burnt umber

Brushes: size 16 flat, size 8 round, size 2 round

Basic shapes

Note the smaller head shape in comparison to the rest of the body, and the larger oval to represent the cheetah's deep, greyhound-like chest.

LION

The lion, or *Panthera leo*, is the second largest of the big cats after the tiger. It has long been a symbol of power, courage and nobility; appearing on flags and royal crests in many civilisations. It has been a familiar logo for a famous Hollywood film studio since the early twentieth century.

The lion is the only cat to show obvious differences between males and females in its appearance: the adult male is easily recognisable by its regal mane. Lions' manes generally darken with age, and they are said to be an indicator of health: the darker the mane, the healthier the lion. It is thought that lionesses are more likely to mate with darker-maned lions for that reason.

Lions vary in colour from tawny yellow to darker browns, and are the only cats to have a tufted tip at the end of their tails.

Male lions are constantly sparring with each other and fighting off rival males. Because of this their faces are usually scarred, something you should watch out for when painting a lion's face. A smooth-faced adult lion will be rare indeed.

Similar and distinguishing features

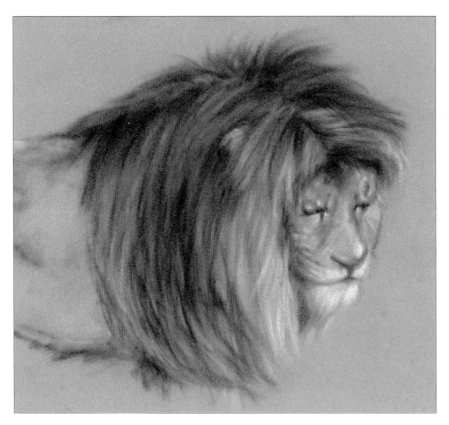

Tufted tail
Note how the strong, thick tail is finished off with an oval of wiry tufted fur.

Lion's mane
Here you can clearly see the front 'fringed' section, and the longer plume of a healthy black-maned lion.

Lion in pastels

1 After drawing the outline and details of the lion's head with a hard black pastel, use the flat side of the same pastel to establish the darker tones.

2 Next, take a cadmium orange soft pastel to give the lion's fur some depth and vibrancy; the sand-coloured paper will serve as the overall buff colour of the lion. Use the same pastel to brighten up the background behind the lion; this will help to bring the head forward.

3 Take the ivory hard pastel, and create most of the highlights. This colour is perfectly adequate for natural highlights in most animals.

4 Finally, use the black and white hard pastels to darken and highlight important areas – mainly ears, eyes, nose and mouth; not forgetting those all-important whiskers of course.

You will need

Sand-coloured velour paper:
 35 x 25cm (13¾ x 9¾in)
Soft pastels: orange
Hard pastels: black, ivory, white

Basic shapes

The basic structure of the mane is broken down into two sections: the front 'fringe', like a Roman soldier's helmet crest, and the longer section behind the head, shaped like a Household Cavalryman's helmet plume.

The finished picture.

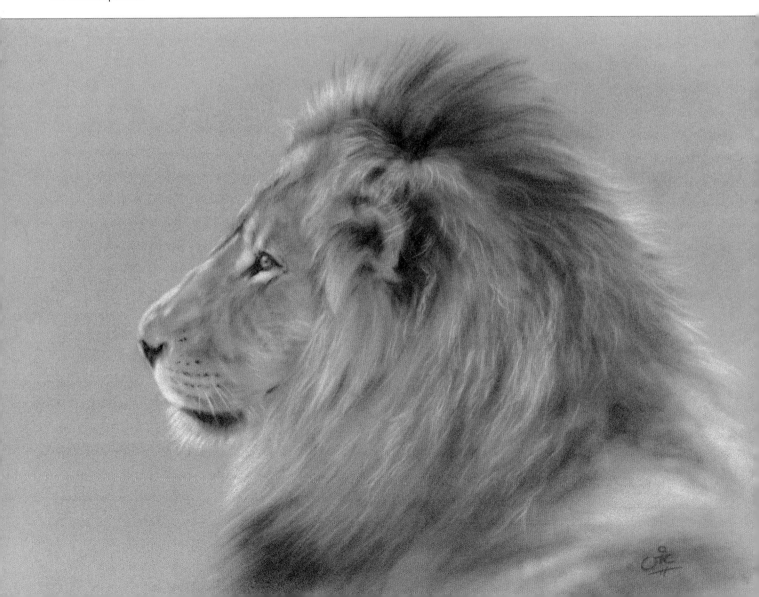

Tiger

Now we are going to paint probably the most iconic and favourite of all big cats, the tiger. Most of us love panting tigers because of their distinctive stripe pattern and colouration – anywhere from pale ivory through to red-orange. The stripe pattern in each tiger is unique, almost like a fingerprint; and the Siberian tiger has the palest coat, being white under the belly.

Before we begin the painting, let's think a little about composition. Whether you are sketching from life or taking reference photographs, try to consider how you can position your subject to create an interesting composition. Below are two examples of the same tiger in different poses. Which do you think will make for the more interesting painting?

You will need
300gsm (140lb) Not surface
 watercolour paper: 30 x 42cm
 (11¾ x 16½in)
Watercolour paints: burnt sienna,
 vermilion, cadmium orange,
 spectrum yellow, burnt umber,
 Mars black, sap green.
Brushes: size 10 round, 15mm
 (½in) short flat, 5mm (⅛in) short
 flat, size 6 round, size 4 round,
 7mm (¼in) round
Drawing board
Masking tape
2B pencil
Masking fluid and old brush

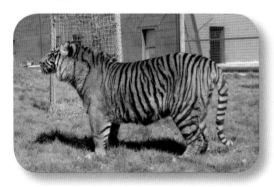

Composition one.

Composition two.

If you chose composition two, congratulations; this is the one that I opted for. The first composition is quite flat and static, producing the kind of painting you might find in a Victorian encyclopaedia on wild animals. The second composition, on the other hand, shows movement and life. This is also an example of the classic 'diagonal composition', enhanced further by the portrait aspect of the paper.

Rather than paint the tiger on white paper, we are going to create some drama in the painting with a paint-spattering effect in the background, using very warm colours to suggest a hot environment.

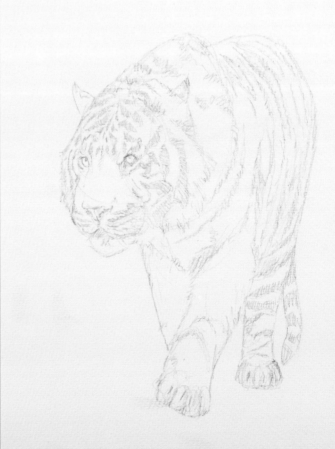

1 Having decided to use the second reference photograph for the painting, we need to translate this into a basic shape sketch. Secure your watercolour paper to the board with masking tape and sketch in the tiger as shown with a 2B pencil.

42

2 Cover the bulk of the tiger with pieces of low-tack masking tape.

3 Use masking fluid and an old size 6 round brush to cover the smaller or harder-to-reach areas. Allow to dry.

4 Lay in a wash of burnt sienna over the whole background with a size 10 round brush. Do not worry about being neat – loose, haphazard strokes will add vibrancy.

5 While the wash is drying, prepare wells of vermilion, cadmium orange and spectrum yellow. Load a 15mm (½in) short flat brush with dilute vermilion. Hold the brush approximately 15–20cm (6–8in) from the surface and draw your finger across the bristles to spatter the surface.

6 Repeat the spattering with cadmium orange and spectrum yellow. Keep the paint dilute so that it springs from the brush in a loose spray.

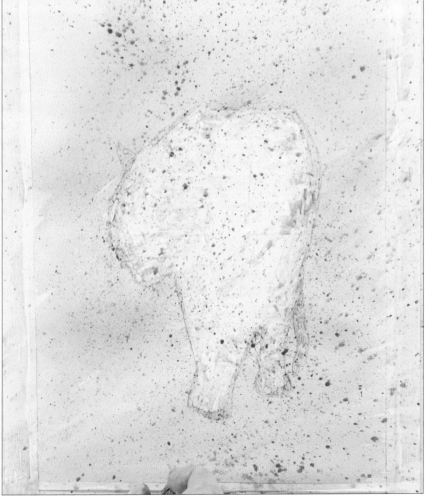

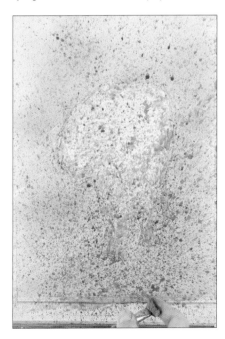

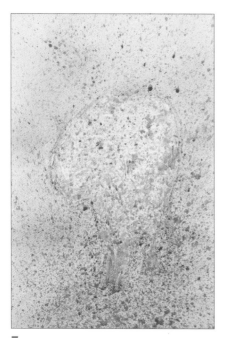

7 While the paint is still wet, spatter more vermilion below the tiger.

8 Allow the paint to dry completely, then carefully remove the masking tape.

9 Use a clean finger to gently rub away the masking fluid. Do not be too vigorous or you risk taking off the surface of the paper.

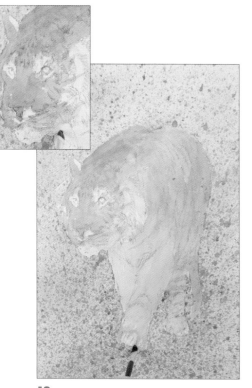

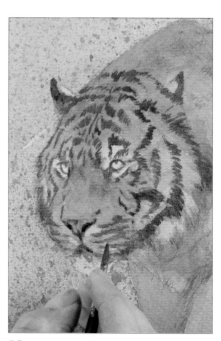

10 Switch to the 5mm (⅛in) short flat and paint the tiger with a warm coat of cadmium orange, avoiding the lighter areas of the face (see inset). Use a clean, wet brush to feather the colour into the lighter-tinted areas of the fur.

11 Allow to dry thoroughly, then glaze burnt sienna over the orange in the stripes for the darker tones. Begin to suggest texture by cutting out basic shapes, such as the tiger's ruff, using the blade of the brush. Note the darker area running down the centre of the tiger's head.

12 Prepare burnt umber, making it slightly less dilute than the previous washes. Begin to sketch in the dark areas of the face using the size 6 round brush. Keep the detail fairly loose, as this burnt umber provides a soft base for the later darker tones. Refer to the fur map on page 37 and use very short, light strokes to suggest the fur texture.

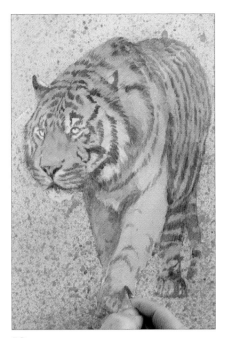

13 Lay in the same burnt umber strokes over the rest of the tiger. Soften any strokes that are too dark or harsh with a damp brush before they dry.

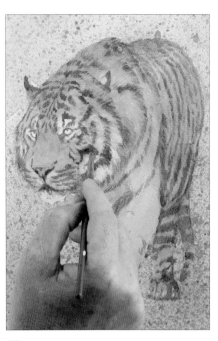

14 Use a clean, damp brush to lift some of the dry darker tones and draw them subtly across the other areas to soften the colour. Use short strokes to reinforce the texture of the fur.

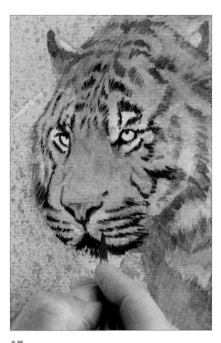

15 Switch to the size 4 round brush and use a nearly undiluted mix of burnt umber and Mars black to strengthen the tone of the dark areas on the face with tiny strokes.

Vic's tip

The paint is used nearly undiluted for strength here. If the brush starts to drag, add a touch of water so it flows smoothly.

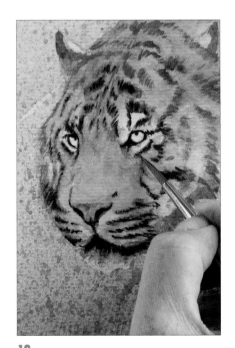

16 Clean and wet your brush and use it to gently soften and feather the very dark strokes on the face.

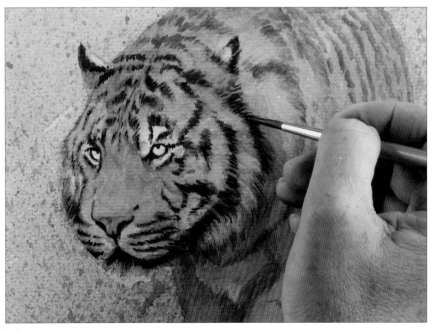

17 Using a slightly weaker mix of burnt umber and Mars black, paint in and soften tiny strokes across the rest of the head. For heavily textured areas, such as the ruff, use the side of the brush.

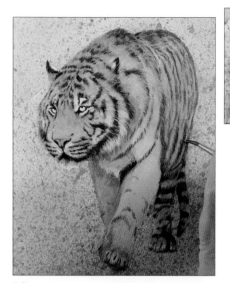

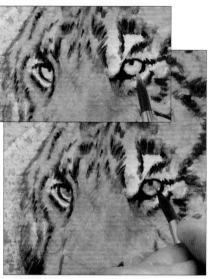

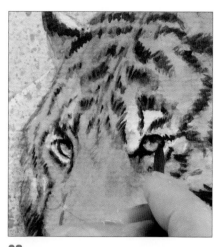

18 Paint in the other dark stripes. The greatest tonal contrast should be at the focal point in the foreground (the face, where the clean white of the paper and near-black strokes lie), so as you work into the background, use more burnt umber and less Mars black in increasingly dilute mixes.

19 Paint the tiger's eyes with spectrum yellow (see inset), then lay on sap green, leaving some yellow at the bottom to show the area of the eye unshaded by the eyelid.

20 Dilute the very dark mix of burnt umber and Mars black and use it to add the shadows that the eyelids cast on the eyes.

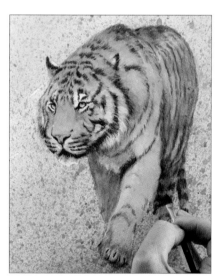

21 Switch to the 7mm (¼in) round and glaze areas that need to be knocked back with dilute burnt umber, such as the foreleg on the left-hand side, the rear leg, tail, the back, hindquarters and behind the ruff.

22 Make any final changes you feel are necessary to finish, such as muting the foreleg on the right-hand side with a dilute glaze of burnt sienna.

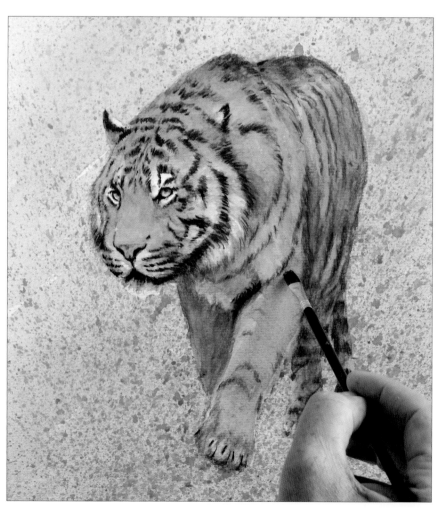

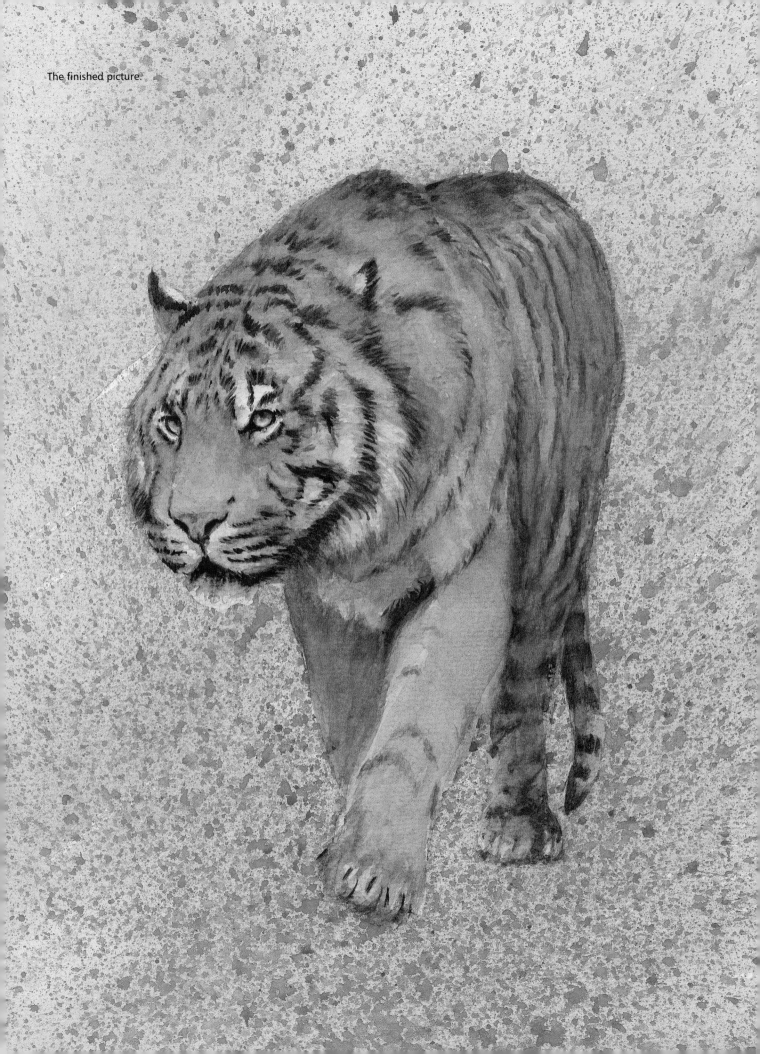

The finished picture.

Ungulates

The term 'ungulates' covers quite a range of mammals, most of which walk on the tips of their toes – the ballet dancers of the natural world. The tips of the toes, or hooves, are covered with keratin. Keratin is the substance that nails are made from, and these nails, rolled over the tip of the toe, provide a hard wall for the animal to walk on.

You have probably seen farm animals with hooves, and recognise them instantly – sheep, goats, cattle and pigs. There are some similarities between these and wild ungulates, as well as some differences. Both giraffes and deer, for example, are even-toed ungulates like the farm animals mentioned above. This means that they all have two main hooves on each foot. Such animals are often referred to as cloven-hooved.

Others, like zebras, rhinoceros and wild horses are odd-toed ungulates. In these animals, the middle toe is larger than the surrounding toes, or has evolved into a single hoof. The advantage for a single-hooved animal is that it can usually run fast, an essential requirement if running is your only defence mechanism.

In this chapter we will focus on possibly the most well-known and often painted wild ungulate, the zebra, or African equid, from the horse family; the most horse-like being the mountain zebra and the plains zebra. The third, Grevy's zebra, is closely related to the donkey.

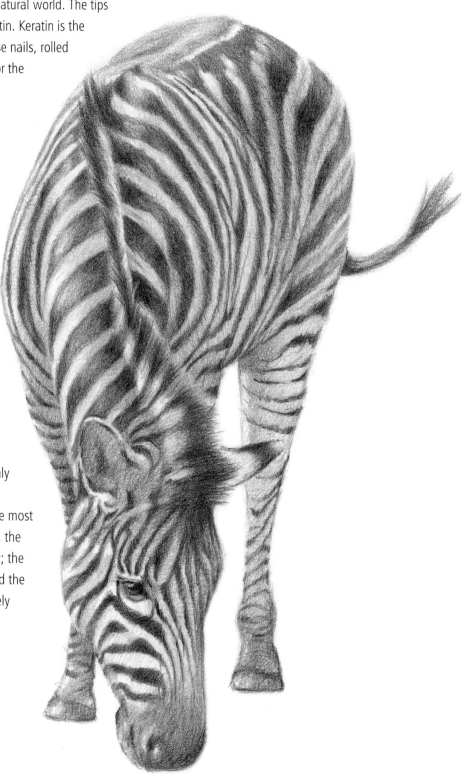

Basic shapes

The zebra's body shape is very similar to that of its relative, the horse.

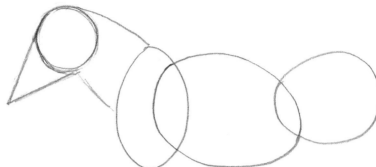

1 Begin by drawing three egg shapes to represent the chest and shoulder section, the mid-section and the hindquarters. Then add a cylinder shape for the zebra's neck, and an ice cream cone shape (circle and triangle) for its head.

2 Add a square to the end of the ice cream cone shape to give the outline of the nose and muzzle, then draw the zebra's mane. This looks similar to a Roman centurion's helmet plume, as it is shorter than a horse's mane. The upper parts of the legs are more muscular than the lower parts, so these are drawn as cone shapes down to the first joint (hock at the rear, knee at the front), followed by a straight line down to the second joint (fetlock). Triangles represent the hooves.

Vic's tip

Look for geometric shapes in your subject. It is much easier to deal with simple shapes in your drawing rather than trying to handle too many details at once.

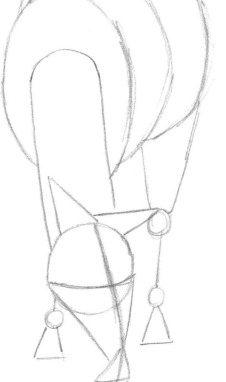

You can build up the basic shapes for a zebra in any pose; and with a little modification, you can use the same method to make a horse. The example to the left shows the basic shapes for the zebra on the opposite page.

Distinctive features

EYES

The majority of ungulates have very appealing, soft eyes; which is why so many people like to paint these animals. Like horses and most other ungulates, zebras have their eyes positioned on the side of their heads. This gives them an almost 360° field of vision, perfect for keeping a look out for lions and other predators.

Typically for this group of animals, zebras have horizontal pupils when contracted, allowing a wider field of vision. When the pupil is fully dilated, it becomes round to fill the eye and let more light in. Let's have a look at drawing the zebra eye in detail, using coloured pencils.

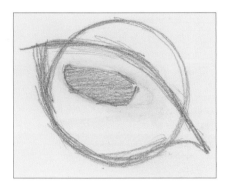

1 Start by drawing a circle to represent the eyeball. It is easier to do this than to try and draw the visible shapes of the eye. As with all animals, the outward appearance of the eye is determined by the eyelids and rims; in this example, an almond-shaped curve for the upper eyelid. Add in the horizontal pupil as shown.

2 Next, establish the warm brown of the zebra's iris using burnt umber over a layer of burnt sienna. Leave a little of the burnt sienna showing to highlight the bottom right of the eye, as the light will be coming from the top left. You can also separate the third eyelid and tear duct from the iris at this point.

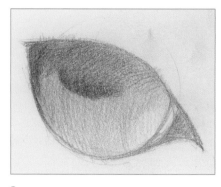

3 As the light is coming from above the eye, you will need to create a shadow under the upper eyelid. I have done this using a black coloured pencil, softly bringing the shadow down to the horizontal pupil.

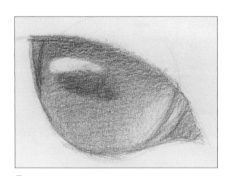

4 Now we can create the reflection in the upper left part of the eye, in line with our light source. Follow the curve of the eyeball with your reflection, and simply use a plastic eraser to rub out the required shape.

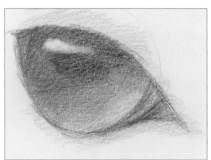

5 For the next part, I have used a Prussian blue coloured pencil to create a cooler area around the eyelid, rim and tear duct, and put a little sky colour into the reflection.

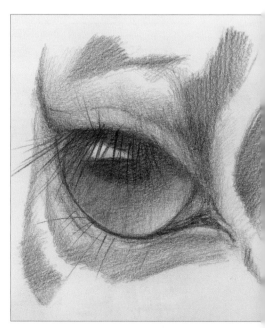

Once the eye is completed you can enhance the whole area, and make it look more like a zebra with a few stripes (black over burnt umber) and long wispy eyelashes.

HOOVES

Imagine running, or even walking on your fingernails: that is exactly what zebras do. Zebras' hooves are hard and soft tissue, covered with very hard keratin, the same substance as our fingernails, forming a wall which supports the weight of the animal. Like our fingernails, the hooves grow continuously, being worn down by daily use. Zebras, like horses, are single-toed ungulates; which means that they walk on one toe per foot – the one with the big toenail.

 As with paws, some people will find drawing hooves difficult, but this need not be the case. Legs and hooves can easily be represented by simple shapes. Let's have a look at the basic shapes in the zebra's lower front leg.

1 In this example, the joint above the hoof (fetlock) is represented by a circle. Draw a straight, slightly angled line through this joint. Using the edge of the line as one side, draw in the other two sides of the triangular hoof. You can almost feel the hoof being able to flex at the apex of the triangle now.

2 Now you can round off your shapes to something more natural-looking. Note how the lower half of the triangle takes on the shape of the keratin wall (fingernail) of the hoof.

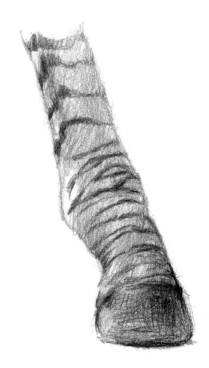

Knowing that you have all the elements of the leg drawn correctly, add shading, colour and markings, and you have the perfect zebra leg. This is always the most satisfying part.

MUZZLES

The muzzle is the area of the nostrils, mouth and chin below the bony bridge of the zebra's nose. Along with excellent hearing and vision, the zebra has a very acute sense of smell. These senses combine to create an effective primary defence shield against lions and other predators.

As with other animal shapes that we use, keeping a balance from one side to the other, with eyes and nostrils for example, is easier if we use geometric shapes. Let's follow the step-by-step guide and see how easy it is to draw the muzzle.

1 First of all, draw in a triangle pointing down. The actual shape and length of the triangle depends on the shape and length of your zebra's nose. The upper horizontal line will be the zebra's eyeline.

2 Next, draw a vertical line through the centre of the triangle. This will help to keep everything lined up correctly.

3 Now draw in a couple of triangles, roughly the same size, so that the bottom of one and top of the other are touching the point of your first triangle. This is the basis for the zebra's muzzle.

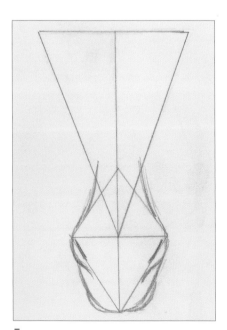

4 At this stage we can start to round off the muzzle to a more natural shape and add in the nostrils, along the sides of the lower triangle.

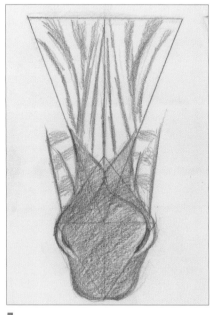

5 Now you can add colour and shading using burnt umber and black coloured pencils. Ensure the stripes and the brown shading above the muzzle begin to fall into your geometric shapes, going into the bridge of the zebra's nose.

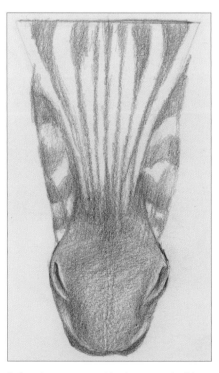

Rub out your geometric shapes and add some more shading and precise shaping to complete your zebra's muzzle.

STRIPE MAP

'Horses in pyjamas' is a popular description of zebras. There are a number of theories as to why a zebra has stripes, the most common being for camouflage. It is even thought that the zebra is black and the white markings are additions. However, what is more important for the wildlife artist is how to draw or paint the zebra's stripes.

Whenever you are drawing or painting animals with a lot of markings, looking at stripes is almost as confusing as seeing spots before the eyes! It can be like trying to paint a barcode, remembering how many stripes there are, how thick or thin they are, and so forth. It helps if you know the patterns of the zebra stripes, so that you understand what is going on. Then even if you can not see them too clearly in your reference, you can still represent them fairly accurately.

The stripe pattern on the head and face. Notice how the stripes converge in the centre of the head, and flow down to the muzzle and around the eyes.

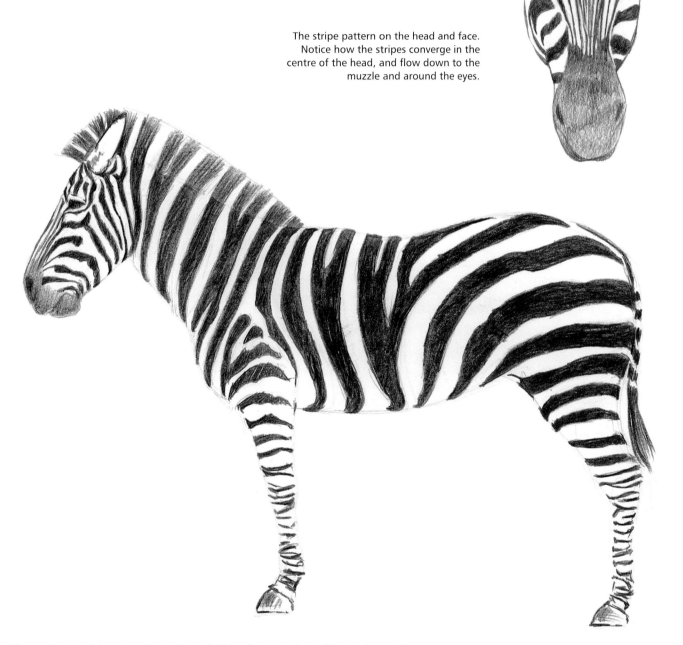

The profile of a plains zebra. Notice first of all the direction of each black stripe, and how they help to show the contours of the zebra's body. They are basically vertical on the head, neck, forequarters and body, with horizontal stripes on the hindquarters and legs.

53

Other ungulates

GIRAFFE

The giraffe (*Giraffe camelopardalis*) is an even-toed ungulate, with two hooved toes on each foot. The giraffe's scientific name is thought to be derived from the words camel and leopard, because of its facial resemblance to a camel and the large spot-like markings on its body.

The giraffe is also the tallest of all the mammals, and males can grow up to 5.5m (18ft) tall, enabling them to graze on leaves which other animals can not reach.

There are various subspecies of giraffe, which have slightly different markings, but they all mostly have brown patches over a lighter background.

Similar and distinguishing features

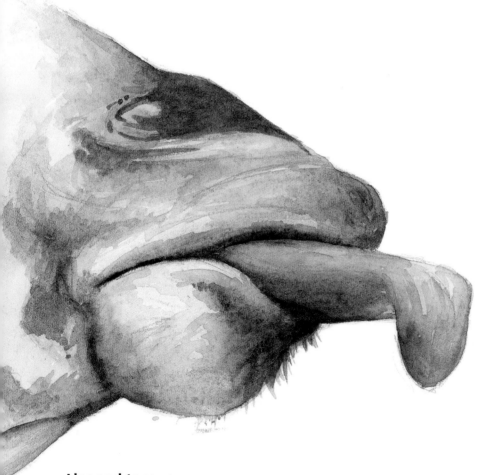

Lips and tongue
The giraffe's tongue is a bluish colour, and like its lips, is very tough. These features enable them to graze leaves from their favourite tree, the acacia, which has sharp thorns.

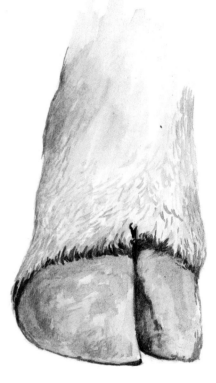

Giraffe hoof
The giraffe's hoof is cloven, that is to say, split into two sections. The hooves are also sharp, and can be used for defence as well as digging for tubers and roots in the ground.

Giraffe in watercolour

1 After sketching the giraffe's head, use burnt sienna and the size 2 round brush to paint in the features, details and markings.

2 Then, using the size 8 flat brush, paint a wash of burnt sienna over the warm areas to create an overall midtone, followed by a wash of Prussian blue to create shadows around the eyes, ears, the shadow side of the face and tips of the giraffe's horns.

3 Gradually add the darker details – the markings, shadows around the nose and mouth, and areas of shadow – using burnt umber. Keep building up the colour until you achieve the depth of tone that you want.

4 Finally, mix burnt umber and Mars black to paint in the final, darker details, which will give you contrast and more depth in your painting.

Basic shape

Note the curved triangle shapes in the nose and muzzle. This is because the giraffe's head is turned slightly.

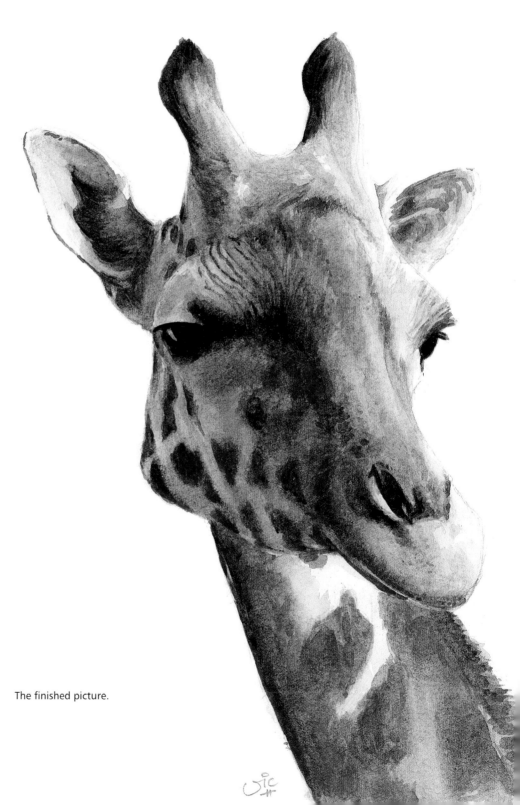

The finished picture.

MULE DEER

People have mixed opinions about deer (*Cervidae*). Some like to hunt them, others, such as myself think they are beautiful animals to look at and paint. Who has not swooned at the sight of a young deer with big brown eyes? I can accept that some deer populations have got out of control; but I believe this is more a result of our efforts to wipe out the deer's natural predators than anything else.

Cervids encompass all kinds of deer, from moose, elk, reindeer, roe deer and white-tailed deer amongst others; and they can be found all over the world. One of my personal favourites is the mule deer, which gets its name from having large, mule-like ears, which are constantly moving, listening for the slightest sound of approaching danger. Mule deer can be found in many parts of western North America.

Mule deer's antlers differ from those of their cousins, the white-tail, in that they form a 'Y' shape, with forks (or tines) growing off the main branches. They also have very good eyesight and a keen sense of smell, all valuable assets for a prey animal.

Similar and distinguishing features

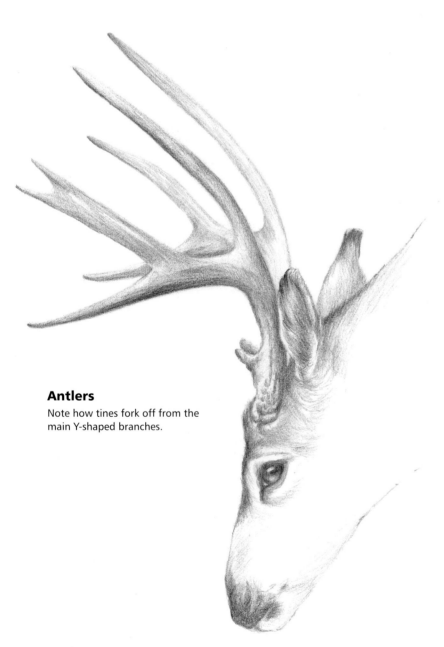

Antlers
Note how tines fork off from the main Y-shaped branches.

Deer hoof
Unlike the giraffe, which also has a cloven hoof, the deer has dew claws on the side of each leg.

Mule deer in acrylics

1 Begin by toning the whole surface with a wash of burnt sienna over a pencil outline of the deer, using the size 16 flat brush – this will give the painting an overall warm tone, as well as sealing the drawing.

2 Paint the background and midground with transparent washes of Prussian blue, sap green and yellow ochre, with titanium white for texture in the mountains, and burnt sienna for texture and details in the trees and grasses.

3 Paint the deer with an overall tone of burnt sienna using the size 8 flat brush, then apply different strengths of burnt umber for darker details with the size 2 round brush.

4 Add further fine details, such as fur texture, antlers and facial features with a mix of burnt umber and Prussian blue, before adding titanium white mixed with a little burnt sienna for the highlights.

5 Build up the foreground grasses in layers using burnt sienna, burnt umber and the titanium white/burnt sienna mix.

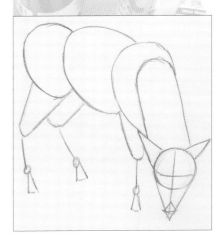

You will need
450gsm (210lb) acrylic paper:
 24 x 32cm (9½ x 12½in)
Liquid acrylic paint: burnt sienna,
 Prussian blue, sap green,
 yellow ochre, titanium white,
 burnt umber
Brushes: size 16 flat, size 8 flat,
 size 2 round.

Basic shape
Begin with the usual three ovals for the body sections. Note the relatively tall triangular hoof shapes which help you to give your deer his dainty feet. Do not skimp on the deer's mule-like ears.

The finished picture.

57

Zebra

Many people imagine a zebra as a white horse with black stripes. However, it is now thought to be the other way round – a black horse with white stripes. It seems logical, therefore, to draw a zebra on black paper (its predominant colour), rather than on white, which can be added over the black. As we saw on page 20, black paper can create a lot of tonal depth and atmosphere to an otherwise potentially flat coloured pencil sketch.

For this project, I wanted to show how complementary colours (Prussian blue and terracotta) interact to give cool shadows and warm highlights that can make the sketch almost glow with light.

I am using coloured pencils, as they show up well on black paper, and also are ideal for sketching short fur texture in a simple way.

You will need

150gsm (90lb) smooth black drawing paper: 30 x 42cm (11¾ x 16½in)
Watercolour pencils: white, burnt sienna, Prussian blue, terracotta
Masking tape
Putty eraser

Vic's tip

A white watercolour pencil will give stronger white tones on black paper than a standard white coloured pencil.

1 Secure the paper to the easel with masking tape, then draw in the zebra using the white watercolour pencil.

2 Use the side of the burnt sienna pencil to add some dark tones to the ears and mane. Hold the pencil quite far back to keep your work loose and free.

58

3 Continue to add warm dark brown areas to the muzzle, eye and neck. These early stages are simply building up the tonal areas, so do not worry about detail yet.

4 Use the Prussian blue pencil to add cool-toned areas to the damp muzzle, and also in the recesses in the musculature as shown.

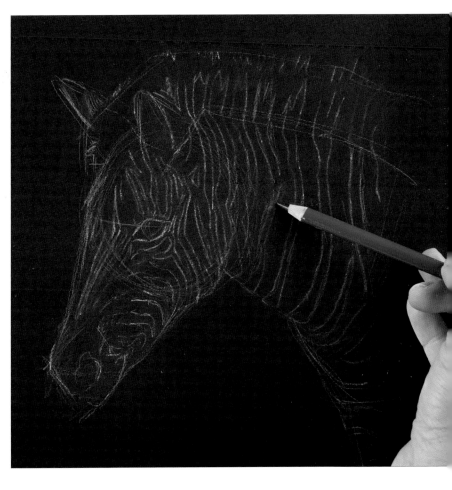

Vic's tip

The more detail you want to apply, the further towards the tip you should hold the pencil.

5 Use the white pencil to block in the white markings on the ears and neck, using more controlled, but still lightly applied, marks that follow the shape of the muscle.

Vic's tip

Work methodically, stripe-by-stripe, to ensure you do not get lost or make a mistake.

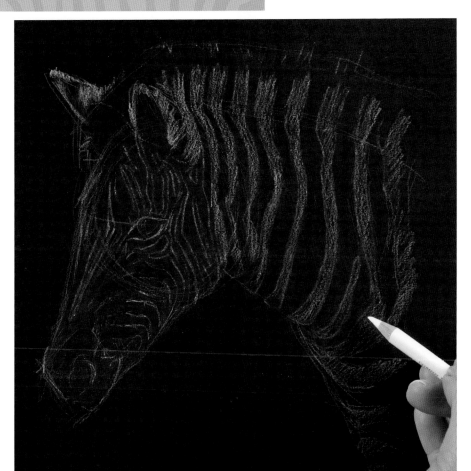

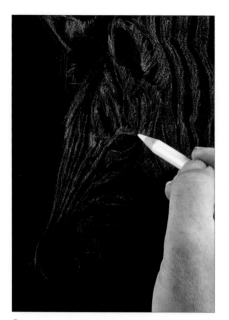

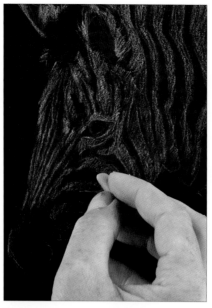

6 Begin to fill in the white areas on the face. This areas is intricate, so it is important to pay particular attention.

7 Shape a putty eraser into a stubby point and use a slight rubbing action to reshape the black stripes and remove the original sketch marks.

8 Holding the pencil near the point, make more controlled, harder strokes to begin detailing the white areas on the ears.

9 Highlight the white areas on the mane, using longer strokes to suggest the texture of the hair.

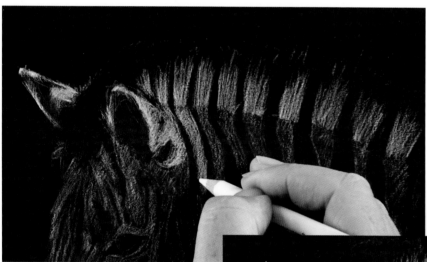

10 Build up the white on the shorter hair of the neck, using shorter, tighter strokes that closely follow the shape of the muscle. Observe the areas of highlights and shadows to build up the contoured shape of the animal.

Vic's tip
Always keep the point of the pencil sharpened. A blunt tip will reduce the pressure you can apply and thus reduce the textural effect, tonal contrast and impact of the finished piece.

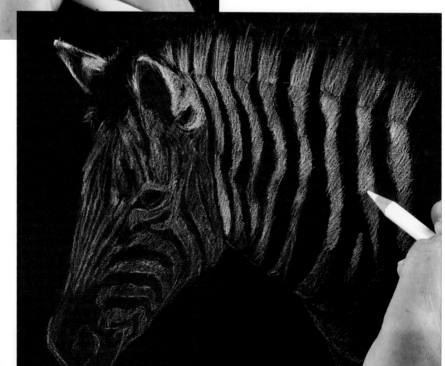

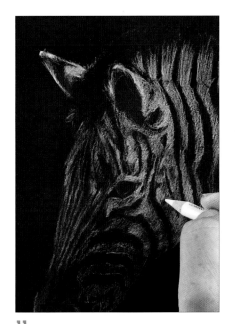

11 Highlight the short hair on the cheek in the same way as the neck, following the muscular contours when applying the colour.

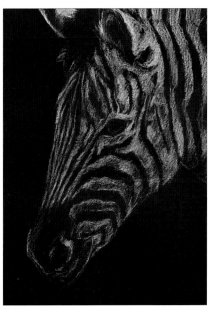

12 The light source is on the top right, so much of the muzzle will remain in the shade. For these areas, use very little pressure so the texture is built up without altering the tone significantly.

13 Start to develop the eye using the putty eraser to remove the underlying sketch lines.

14 Use the burnt sienna watercolour pencil to add a base colour to the right-hand side of the eye.

15 Switch to the terracotta pencil and build up subtle midtones, again concentrating on the right-hand side.

16 Add a reflected highlight of white to represent the glossiness of the eye.

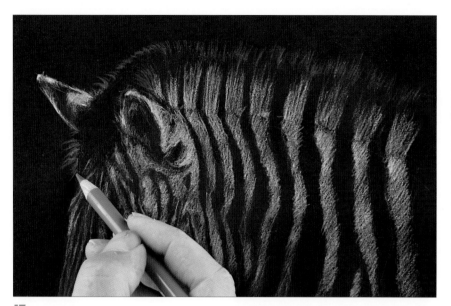

17 Using the terracotta watercolour pencil, add long vertical strokes to the mane, to show sunlight shining on and through it. Use more pressure and shorter, harder strokes to the left-hand side, on the top and on the front of the mane.

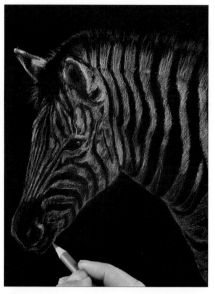

18 Add reflected sunlight to the bottom of the neck and jaw with the terracotta pencil, applying it quite strongly to the white areas. Follow the shape of the neck to suggest the roundness of the neck and jaw.

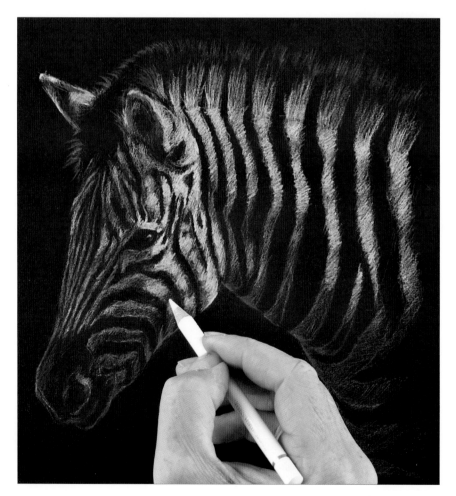

19 Use a sharp white pencil to apply intensify the highlights on the white areas in direct sunlight. Use this stage to emphasise the tonal contrast and develop the impression of musculature.

Opposite
The finished picture.

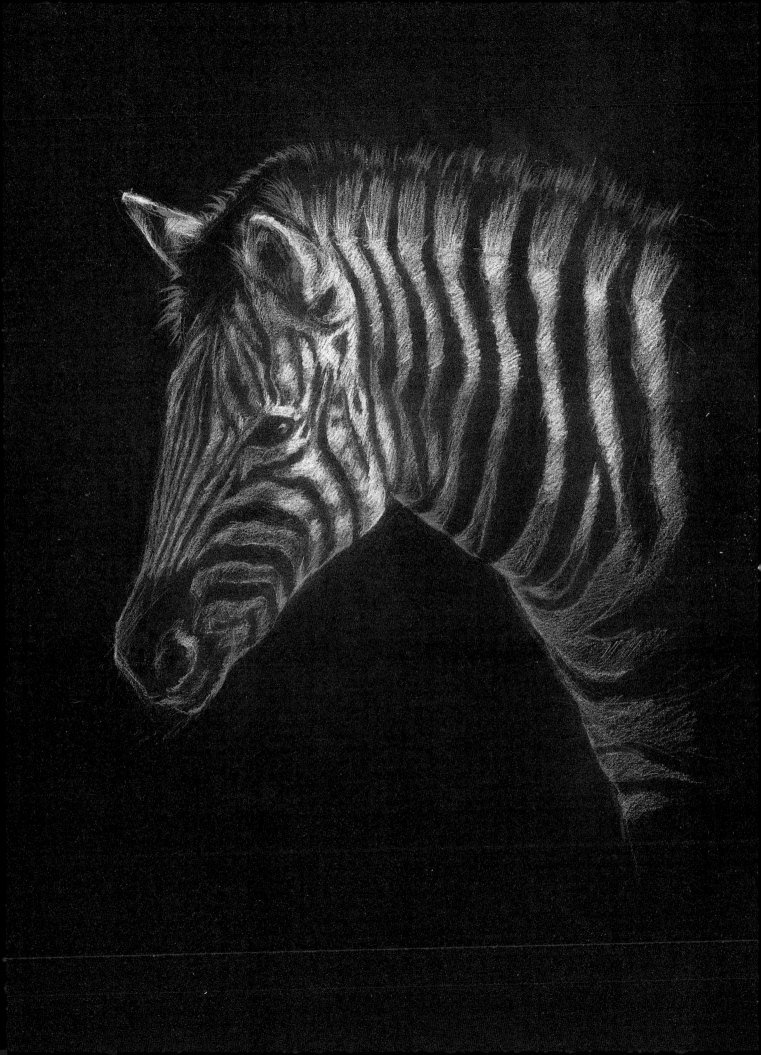

Bears

Bears are animals that we feel we know very well. Many of us have owned our own teddy bears as children, and such is our familiarity with toy bears and cartoon bears, that we are fairly comfortable drawing our fluffy childhood companions using simple shapes.

Real bears come in all shapes, sizes and colours. The family *Ursidae* contains several species, including the black bear, brown bear and polar bear, among others. Bears are mostly found in forests in the northern hemisphere, with some species living in South America and Asia; the latter being the home of the giant panda. The polar bear is a notable exception, being found near the Arctic Circle.

The giant panda (*Ailuropoda melanoleuca*) is one of those iconic animals that everyone immediately recognises. It is a symbol for animal conservation worldwide and has been a popular subject in wildlife art for many years. Unfortunately the giant panda remains on the endangered list. This is partly due to the destruction of its habitat, and also its low birth rate, both in the wild and in captivity.

There has always been some debate as to whether the giant panda is actually a bear, even though it has often been called a 'panda bear'. For a long time, the panda had been thought to be related to the raccoon, but recent DNA studies have shown that it does in fact belong to the bear family.

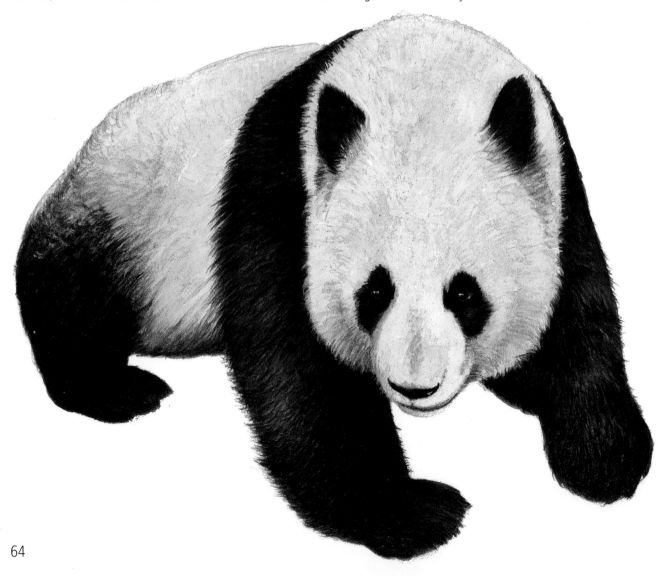

Basic shapes

Most members of the bear family have similar body shapes, and the overall body shape of the panda is typical of bears in general: large, round, heavy-set body, longish snout, rounded ears, stocky legs and a big head.

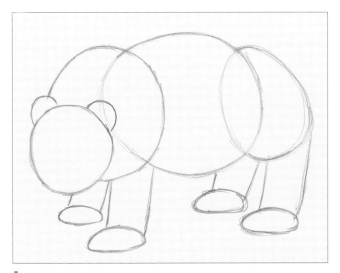

1 The panda's body is constructed using three egg shapes of different sizes. These can be arranged according to the pose you want – with one behind the other at various angles. Note the large round head, rounded ears, and legs represented by thick cylinders, while the feet are flat ovals.

2 Now you can add an oval to represent the panda's snout, with a wide triangle shape for the nose. Indicate the angle of the head using a curved vertical line and a curved horizontal eyeline. Finally, here I have drawn in the spine line through the shoulders and across the back to show how quickly you can get to that classic bear shape.

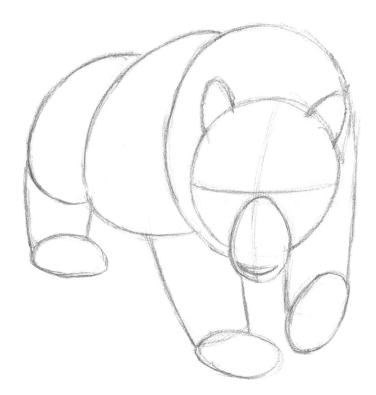

The very rounded face that we associate with the giant panda is due to the very strong jaw muscles they need to make short work of the fibrous bamboo on which it feeds. This example shows the basic shapes underlying the giant panda opposite, and the method used is exactly the same as described above.

Distinctive features

NOSES

Unlike other bears, the panda's nose is quite broad and flat. Because the nose pad is both black and cool, it is a good idea to 'underpaint' with a dark Prussian blue before applying any black. This will help to achieve a cool nose, and also prevent it from looking flat in tone.

1 The basic shape to start with looks like a pair of blue human lips, or a diamond shape.

2 Place two broad, narrow triangles to represent the nostrils.

3 Round off the top part of the nose pad to a curve. This shows the shallow dip between the nasal bones.

4 Round off the bottom of the nose pad and emphasise the line through the centre which joins the cleft in the upper lips.

5 Now the nostrils can be rounded off to a more natural teardrop shape.

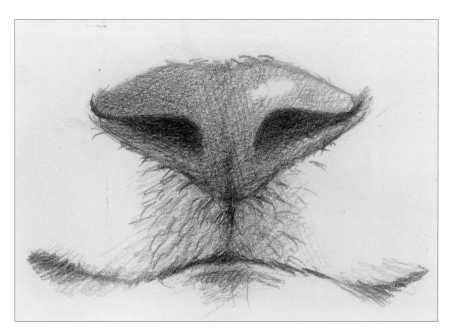

A detail of a completed nose with the addition of shading (black over blue) and highlights. This picture shows the nose pad in place, to show how it connects with the lips and mouth.

EYES

Although not always easy to spot, because of its dark brown eyes, the panda's pupils are vertical slits, like those of a domestic cat. It is likely that this might help with their night vision. However, generally, pandas are thought to be short-sighted. Now we will have a go at drawing the panda's eye, using coloured pencils.

1 Begin, as always, with a circle to represent the eyeball shape. Next add in the pupil, which in this case is more of a vertical slit than a round pupil.

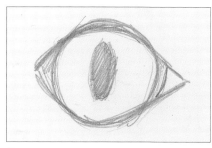

2 Next, shape the eyes with upper and lower eyelids, before adding in the tearduct shape and a hint of the third eyelid in the corner.

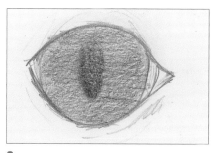

3 Now we can add some colour to the eye using a burnt sienna coloured pencil.

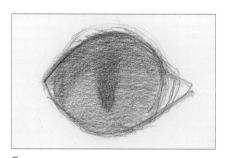

4 If we assume that the natural light is coming from above the panda, then we need to add some shadow in the upper part of the eye with a black coloured pencil.

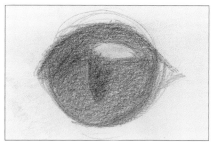

5 Again, as the light is coming from above, rub out a slightly curved reflection with a hard plastic eraser.

Vic's tip

If you are having difficulty drawing circles for eyes freehand, collect a variety of circular objects – lids or coins etc. – in different sizes. You can then simply draw round these as needed.

Finally, add some more depth of shading with the burnt sienna and black. Before sketching in the dark eye patch, put a hint of the dark Prussian blue on the paper first.

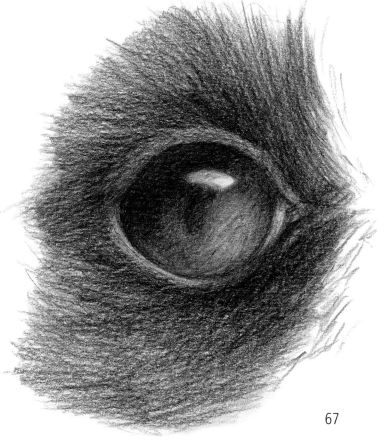

FEET

Bears are plantigrade, which means that they walk on the palms of their feet, rather than on their toes, or nails like other animals.

Bears have sharp non-retractible claws, ideal for climbing and digging for vegetation. Those claws can also cause a lot of damage to prey and humans alike. Panda's feet also have a protruding part of their wrist bone, which acts like an opposable thumb. This feature enables the panda to firmly grasp its favourite food, bamboo.

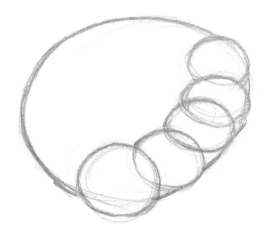

1 All bears have five toes on each foot. Drawing a bear's foot is very simple. Start by drawing a large oval shape, with five smaller ovals to represent the toes.

2 Next, draw in the claws towards the top and front of each toe.

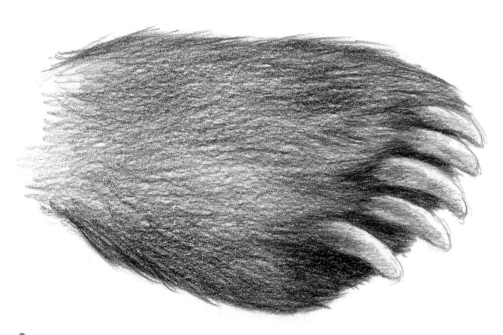

3 Finally, add some shading and fur texture. In this case, blue-black for a panda.

Examples of panda feet

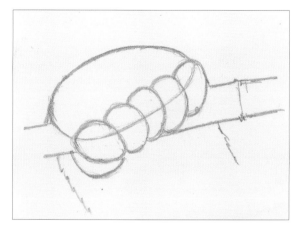

Here is the foot holding a stick of bamboo, drawn using basic shapes. Note the wrist bone beneath the bamboo.

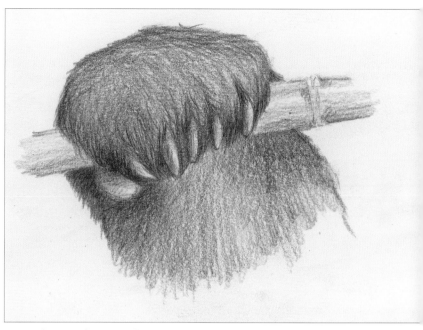

Here is the same foot with claws, shading and texture added.

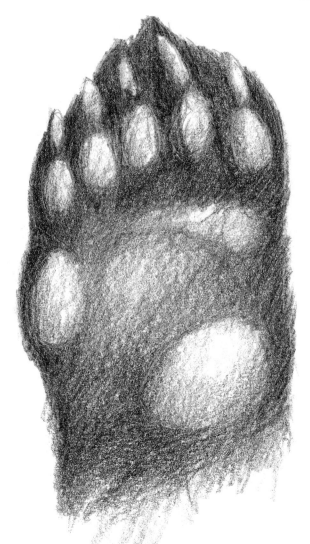

The panda's extended wrist bone, used like an opposable thumb to grasp objects, is visible on the left here.

Other bears

POLAR BEAR

Polar bears (*Ursus maritimus*, or maritime bear) are closely related to brown bears, and live mostly within the Arctic Circle. Like the giant panda, the polar bear is an instantly recognisable and popular animal; and, again like the panda, is under threat through loss of habitat.

The polar bear is the largest land carnivore, weighing up to 680kg (1,500lb) and reaching up to 3m (9ft 10in) in length; and yet it is a much sleeker-looking animal than its cousin the brown bear, with a smaller head and longer neck.

Polar bears have adapted well to living in a cold climate. They have a dense undercoat of soft fur, over which grows yellowish-white fur, topped with transparent guard hairs, which are very reflective, picking up strong white highlights and blue reflected light from the environment. The polar bear's skin is actually black. Although difficult to see in most areas; this helps them to absorb heat from the sun. Their paws are larger in diameter than other bears, to help spread their considerable weight over the ice, like snowshoes, and also to act as paddles when swimming.

Similar and distinguishing features

Body shape

Polar bears have a sleek body shape, with a longer neck than most bears, with a relatively small head. Ovals are used for the principle body shapes, with a circle for the head and cylinders for the neck, nose and legs. Once the spine line has been added, you can clearly see the recognisable polar bear outline.

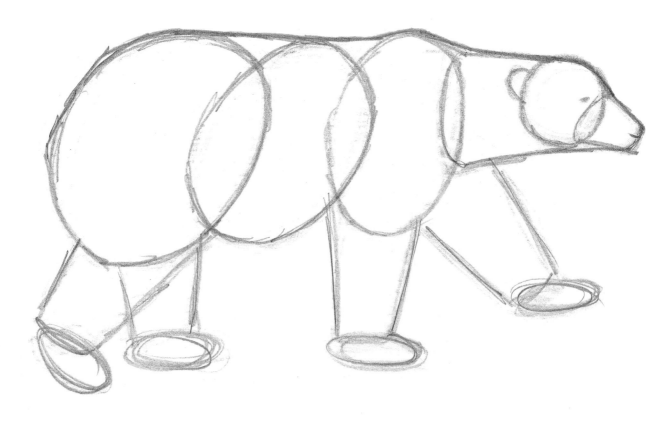

Polar bear in pastels

This is a good example of using cool and warm colours to create atmosphere in a drawing or painting. The picture has a base of dark grey paper and uses Prussian blue in the shadows. Both help to give a cold, almost icy feel to the sketch. Only where the low Arctic sun is highlighting the fur, from behind and left, have I used yellow and ivory, the natural fur colour.

Pastels are very good for drawing thick clumps of fur, and velour paper helps make the fur appear soft. Look closely at the area around the ear. The shadows, which create the outlines of individual clumps of fur, are drawn with a hard black pastel, used finely in places and thicker in others. Highlights are indicated on top of the midtone colours with a white hard pastel to give the appearance of three-dimensional clumps of fur.

1 Begin by sketching the basic shapes and features of the polar bear using the hard black pastel. Add in the soft shadows around the ear, eye and muzzle area at this stage.

2 Using the side of the soft Prussian blue pastel, apply one or two soft, transparent coats over the shaded part of the polar bear's fur.

3 Use the yellow ochre soft pastel to begin highlighting the edges of the fur; this will also create a backlighting effect from the low Arctic sun.

4 Finish the finer details around the ear, eye, nose and mouth with the corner of the hard black pastel.

5 Use the ivory hard pastel to create lighter soft highlights in the fur, and sharper, harder highlights on the bear's nose which, of course, is bone and cartilage.

6 Finally, use the white pastel sparingly for impact highlights, such as the shine on the nose and the condensation from the polar bear's mouth.

You will need

Dark grey velour paper: 35 x 25cm (13¾ x 9¾in)
Soft pastels: dark Prussian blue yellow ochre
Hard pastels: black, ivory, white

Basic shape

The polar bear's snout is longer than other bears, and is slightly arched in the middle between the forehead and muzzle.

The finished picture.

SUN BEAR

The sun bear (*Ursus malayanus*) is the smallest of the bear family, originating from south-east Asia, and gets its name from the yellowish crescent shape on its neck, which is thought to look like the rising sun. Although its overall body shape is obviously bear-like; compared to its larger, better known cousins, the sun bear has some unusual physical characteristics.

Sun bears are mainly tree-dwellers, and they have large paws with long, curved claws, which are excellent for climbing, as well as tearing into tree trunks and logs to search for insects.

Also known as the 'honey bear', because of its fondness for that particular sweet treat, the sun bear has a very long tongue to reach into beehives as well as termite nests. One of the sun bear's more peculiar features is its loose, wrinkly skin, like that of a shar pei dog. If the bear is grabbed from behind, it can literally turn in its skin to bite its attacker with its large canine teeth.

Sun bears are mostly nocturnal, and their eyesight is quite poor, which gives them a tired 'morning after the night before' look.

Again as we see all too often, destruction of habitat is a major problem for the sun bear. People have also tried to keep sun bears as pets but despite their size, they are probably the most aggressive of all bears – so it is perhaps not such a good idea.

Similar and distinguishing features

Size
The sun bear's general shape and colouring resembles that of other bears, but the sun bear is a lot smaller. For the illustration below, I have used the following coloured pencils; Prussian blue, burnt sienna and black, with a combination of sap green and Prussian blue for the foliage.

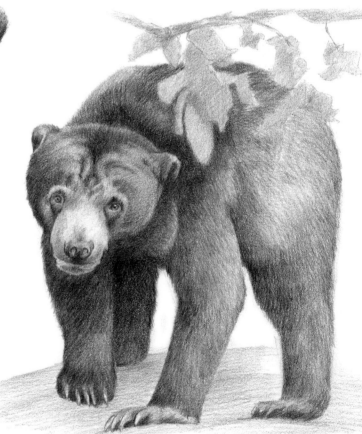

Skin and eyes
The sun bear has very wrinkly skin, and small, tired-looking eyes. This portrait is drawn using the same coloured pencil combination as in the sketch to the right.

72

BLACK BEAR

The black bear (*Ursus americanus*) is probably the one most people are familiar with, especially as it is the 'ancestor' of our childhood teddy bear; becoming forever associated with the American President Teddy Roosevelt after he refused to shoot a black bear cub. It is also North America's most common bear.

Similar and distinguishing features

Face and neck

The black bear has a body shape similar to that of the polar bear, except with a shorter neck, larger, pointed ears and thicker fur. I have used acrylics to paint this head study, beginning with a burnt sienna wash for the overall tone, followed by an ultramarine blue glaze to give a general blue-black tone. Fur texture and details have been painted using Payne's gray, with final tonal glazes in Payne's gray and burnt umber.

BROWN BEAR

The brown bear (*Ursus arctos*) can be found in Europe, Asia and North America, where it is better known as the grizzly, because of the 'grizzled' or grey tips of its brown fur.

Similar and distinguishing features

Face and shoulders

Although the brown bear is closely related to the polar bear, its appearance is quite different, having a long upturned snout with a pronounced forehead, and a recognisable shoulder hump. Similar acrylic colours have been used as in the black bear head study (above), except that I used more burnt umber than French ultramarine, as well as burnt sienna to give an overall browner tone.

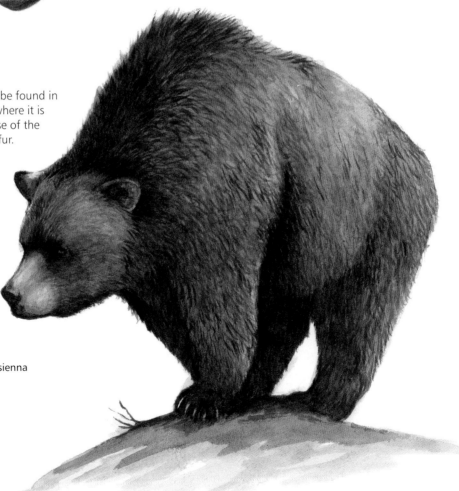

Panda

Even if you are not a landscape artist, adding a simple, effective background will add a lot to your animal paintings, as I hope to show you in this project. I have quite a number of photographs of pandas lounging in the tops of trees in zoos. In order to create a natural-looking painting from these references, a little research will provide you with information on the panda's environment, mountain shapes, appropriate colours and so forth.

I composed this painting based on the principles on pages 30 and 31 for the painting *Mountain Retreat*; that is, to place the subject (in this case the giant panda) off-centre, to the right of the painting.

You will need

450gsm (210lb) acrylic paper:
 40 x 26.5cm (15¾ x 10½in)
Acrylic paints: burnt sienna, ultramarine
 blue, Prussian blue, chromium oxide
 green, titanium white, burnt umber,
 yellow ochre, Payne's gray
Brushes: 15mm (½in) short flat, 15mm
 (½in) long flat, size 6 round
Masking tape
Drawing board
HB pencil

1 Secure the paper to your board with masking tape, then sketch the panda, tree and background on to the paper using an HB pencil.

2 Use the 15mm (½in) short flat brush to apply dilute burnt sienna over the whole surface. Allow to dry.

3 Use the same brush to lay in a dilute wash of ultramarine blue on the sky and allow to dry.

4 Glaze ultramarine blue over the sky again, avoiding the main shapes of the tree, horizon and panda.

5 Lay in a dilute wash of Prussian blue over the mountain in the background. Again, allow to dry before continuing.

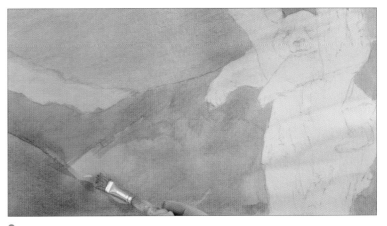

6 Add a little burnt sienna to Prussian blue and lay in a dilute wash over the hills in the midground and foreground.

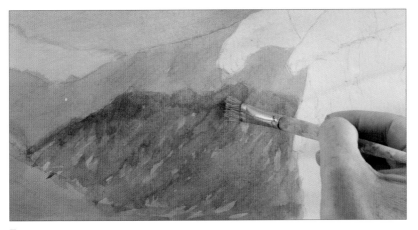

7 Add chromium oxide green to the Prussian blue and burnt sienna mix, making it less dilute than before. Once the hills are dry, texture the foreground hills by dragging near-dry paint in short, ragged diagonal strokes to generate the feeling of movement. Vary these strokes with curt vertical strokes to represent distant trees.

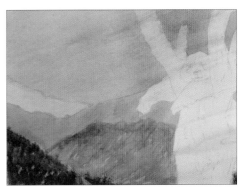

8 Add a touch more burnt sienna and detail the foliage in the lower left- and right-hand corners in a similar way. Vary your brushstrokes with stippling to create random sprays of greenery.

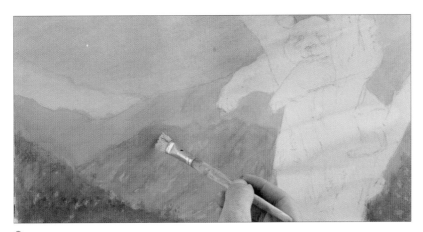

9 Dilute titanium white and lay a glaze over the whole painting to knock it back and help to merge the colours.

10 Once dry, lay in a second glaze of diluted titanium white over the lower half of the sky and the rearmost mountains.

11 Allow the paint to dry, then lay in further glazes of titanium white over the sky. Do not overglaze. You are aiming to create the impression of a spring sky – cool, but not cold.

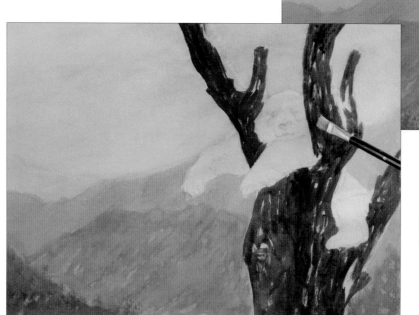

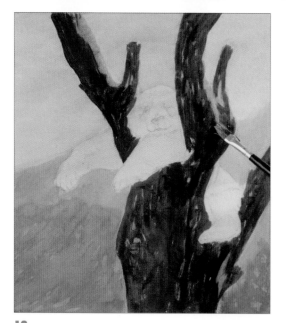

12 Switch to the 15mm (½in) long flat brush and dilute burnt umber to the consistency of single cream. Use this to sketch in the main trunk and branches of the tree, leaving the upper left-hand sides clean. Work loosely, leaving a few gaps here and there to suggest the texture of bark.

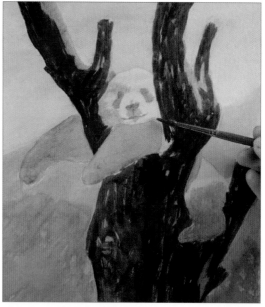

13 Dilute ultramarine blue and use it to develop the bark, washing over the upper left-hand sides and glazing some areas of the burnt umber.

14 Once the underpainting of the tree has dried, use the same brush and ultramarine blue paint to paint in the black areas of the panda's fur. Switch to the size 6 round brush to paint in the facial features and the shadows on his cheek and brow.

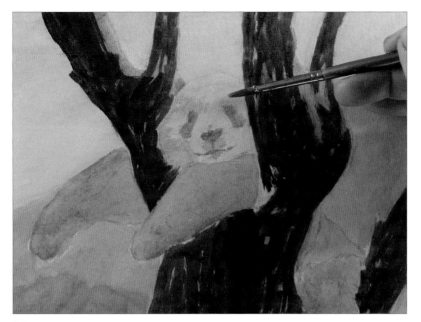

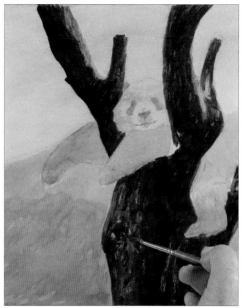

15 Use yellow ochre to lay in a dilute wash on the white areas of the fur, still using the size 6 round brush.

16 Start to detail the tree using the size 6 round brush and Payne's gray. Use the paint only slightly diluted so that the underlying colours show through a little. Texture the tree with directional strokes that echo and emphasise the shape of the tree, and apply the dark colour away from the parts of the tree in the light.

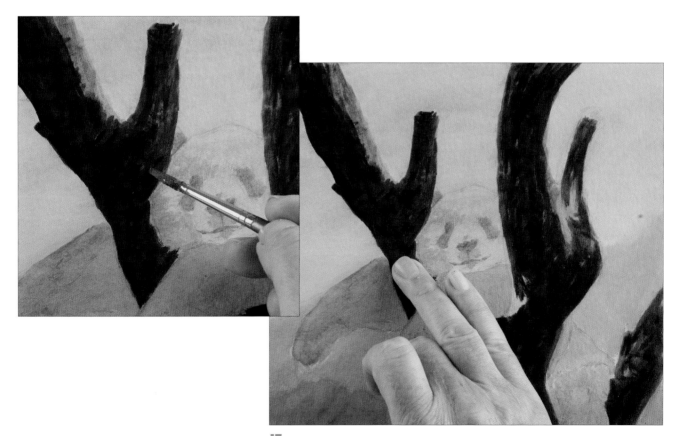

17 Switch to burnt sienna, slightly thicker in consistency than the Payne's gray. Use this to make lots of small strokes to create texture in the midtones (see inset). When the strokes are nearly dry, smudge them in with a clean finger, following the shape of the tree.

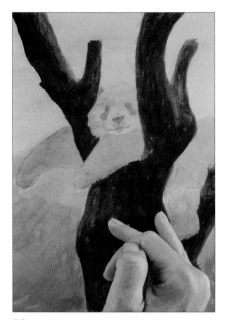

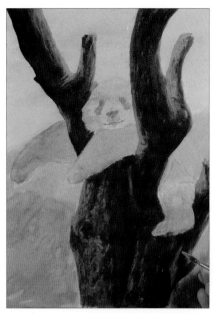

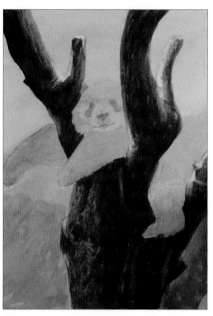

18 Build up midtones over the rest of the tree in the same way.

19 Add burnt sienna to titanium white and build up initial highlights over the tops of the midtone areas. As with the midtone strokes made earlier, make many small strokes and blend them in with your finger before they are completely dry.

20 Add more titanium white to the mix and create final highlights on the tree in the same way, covering some, but not all, of the initial highlights.

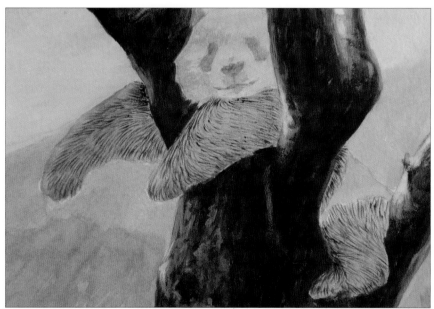

21 Begin to create the fur texture on the foreleg on the left-hand side. Dilute Payne's gray to a single cream consistency and use the size 6 synthetic round brush to draw fine strokes along the arm. The fur runs from the shoulder to the paw, so follow the shape of the arm to guide the direction of each stroke.

22 Continue the base layer of fur over the rest of the black areas of the body and limbs in the same way, paying careful attention that the fur flows correctly.

Vic's tip

Use your reference pictures to help you create a convincing rendition of the way the fur of the panda lies.

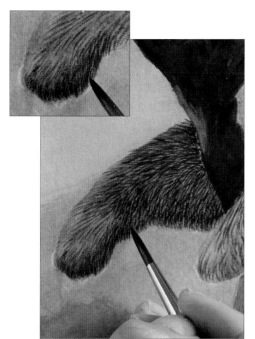

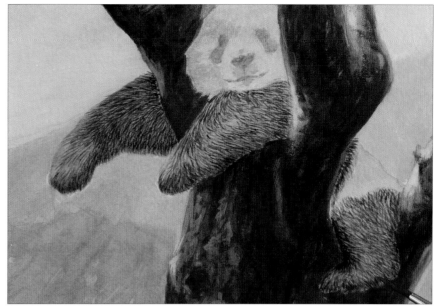

23 Build up the fur on the left-hand foreleg with a second layer, repeating the method detailed in step 21, but using shorter, more densely packed brushstrokes. Work from the outside edges inwards, so each layer of short strokes overlays the previous layer (see inset). Leave some of the underlayer showing through in areas in direct sunlight as shown.

24 Build up the fur on the other black areas of the body in the same way, following the direction of the fur carefully.

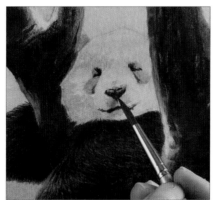

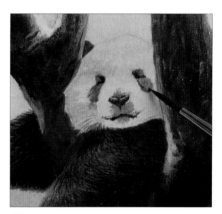

25 Still using the size 6 synthetic round brush, glaze the black areas of the body with very dilute Payne's gray to strengthen the tone. You may need more than one glaze to achieve the depth required. If so, ensure each layer is completely dry before adding the next.

26 Indicate the panda's features with Payne's gray diluted to the consistency of single cream.

27 Glaze the darker areas of fur on the face with dilute Payne's gray, preserving a little of the blue underpainting.

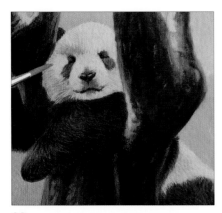

28 Using fairly thick titanium white and the size 6 synthetic round brush, develop the white fur. Do not try to suggest individual hairs, but evoke glowing sunlight by using soft, short strokes on the areas where light hits the fur.

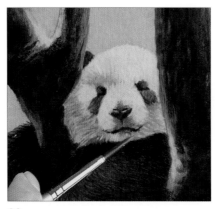

29 Pick up the colour reflected from the tree on the white fur highlights, using very dilute glazes of burnt sienna on the areas of the cheeks nearest the bark.

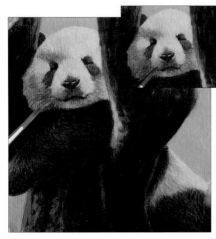

30 Once dry, reinforce the warmth on the face with glazes of burnt umber on the muzzle and areas of shadow (see inset), then use pure titanium white to add tiny impact highlights to the white fur.

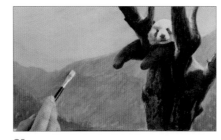

31 Use the 15mm (½in) long flat brush to apply dilute ultramarine blue to the middle distance. Draw the paint down from the ridge into the valley to create texture, blending it downwards with a clean finger.

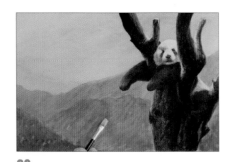

32 Add more paint to the mix to make it less dilute and add texture to the hills in front in the same way.

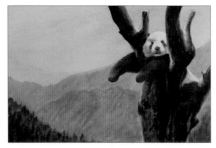

33 Add sap green to the mix until you have the consistency of single cream. Use short rapid upward strokes to suggest trees in the corners of the foreground, then glaze ultramarine blue mixed with a little Payne's gray to enrich the shaded areas of the trees.

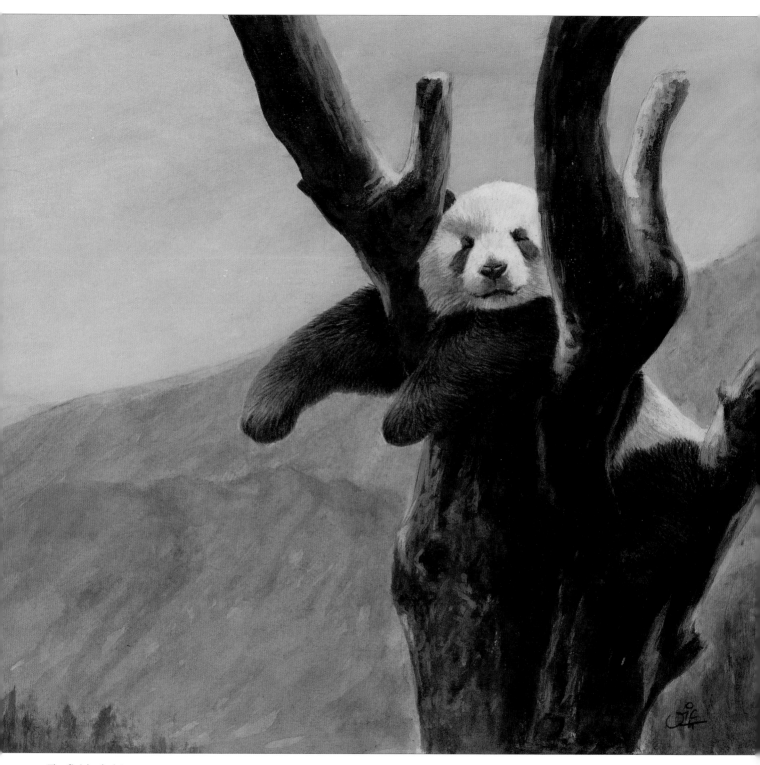

The finished picture.

Pachyderms

The word pachyderm means 'thick skin', and, although it is no longer a scientific classification, it is a useful term to group together large, thick-skinned hoofed animals, such as elephants, rhinoceros and hippopotamuses.

Some of us will have seen elephants in circuses at some point in our lives, as they are highly intelligent and trainable; indeed, they need a lot of this type of stimulation in zoos to prevent psychological problems. Thankfully, these days, there are fewer performing elephants in circuses around the world, although they are still a popular tourist attraction in some Asian countries. Although we are used to seeing elephants as wise and gentle giants, they are in fact, among the world's most dangerous animals.

There are two main species of elephant, the African *loxodonta africana*, and Asian elephant *Elephas maximus*.

Elephants have particularly thick and tough skin, about 2.5cm (1in) thick. African elephants' skin, although grey in colour, often appears to be a red-brown in the wild, as a result of wallowing in red-coloured mud.

Elephants' eyesight is moderate, but they have very good hearing and a keen sense of smell, as well as being able to detect low-frequency vibrations through the pads of their feet.

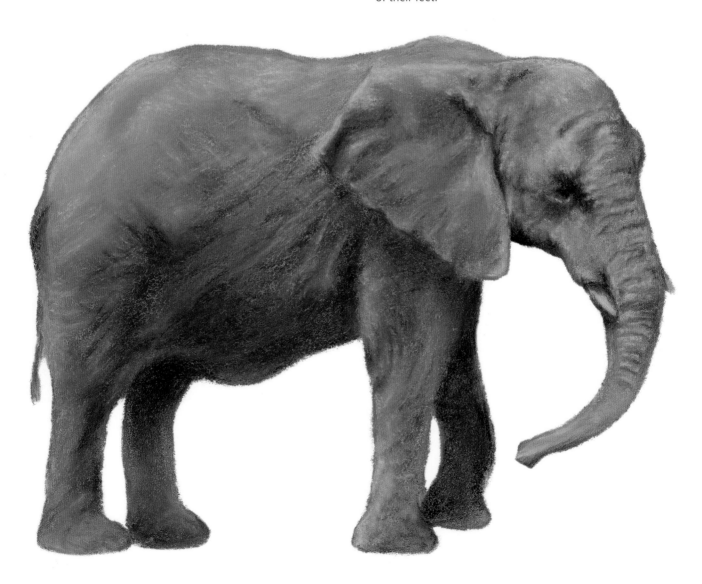

Basic shapes

To the right are the basic shapes of a young African elephant as seen from the front. Note the arrangement of oval shapes, one behind the other, the triangular shaped ears and the elongated 'snout' shape.

As with the other animals in the book, the basic shapes used can be rearranged to allow a great variety of poses.

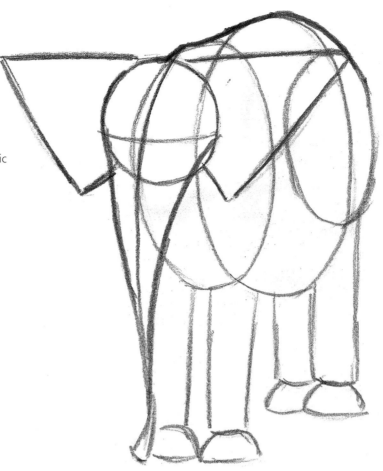

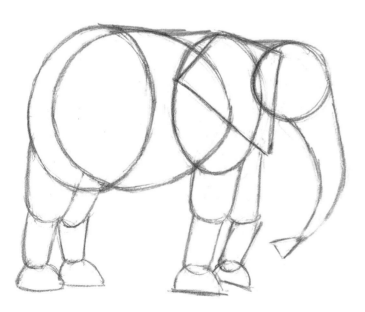

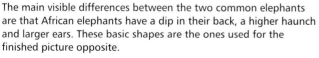

The main visible differences between the two common elephants are that African elephants have a dip in their back, a higher haunch and larger ears. These basic shapes are the ones used for the finished picture opposite.

In comparison, Asian elephants have a more rounded, arched back with a lower haunch and smaller ears. In fact, apart from the sparse hair, the Asian elephant resembles the woolly mammoth, to which it is related.

Distinctive features

FEET

Elephants' feet are almost circular in shape, with soft, spongy pads on their soles for support and noise reduction. Again, there are differences between the two types: African elephants have four nails on the front foot, and three on the back while Asian elephants have five nails on the front foot and four on the back.

1 When you are drawing or painting the legs and feet of an elephant, imagine they are like the supporting columns of an imposing building, strong, heavy plinths with solid bases, capable of carrying enormous weight. Begin by drawing the basic 'column and base' shapes.

2 Add the toenails, the visible parts of the elephant's toes. Remember that an African elephant has four on each foot. These can be drawn initially as semi-circular shapes. Indicate the position of the ankle joint with a circle just above the foot; this will help to correctly place the folds and wrinkles of the skin. You can now add some basic colours, using Prussian blue and terracotta coloured pencils.

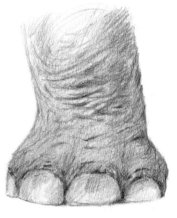

3 Add in the folds and wrinkles, following the rounded shape of the ankle, using a black coloured pencil. Finally add more detailed texture and shading with all three colours to complete the elephant's foot.

TRUNKS

The elephant's trunk (proboscis) is its most useful appendage, able to pick up a single blade of grass, or tear the branches off a tree.

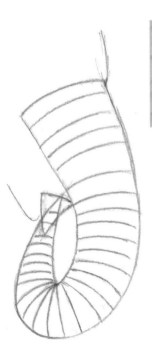

Vic's tip

When drawing an elephant's trunk, it is useful to picture in your mind a bendable plastic tube with wire loops inside. This will help you to draw the trunk in almost any position.

1 The trunk is a fusion of the nose and upper lip. As with other animals' snouts, it can be represented by a triangle shape (albeit much elongated) and curved; with a reversed, smaller triangle for the tip. The 'wire loops' can then be added to show the shape of the trunk and curves of the wrinkles.

2 Make the wrinkles a little more natural-looking, using a black coloured pencil, then use a terracotta coloured pencil to shade the the warm areas of the trunk and add reflected highlights beneath the bend. Indicated the cool shadow areas with a Prussian blue.

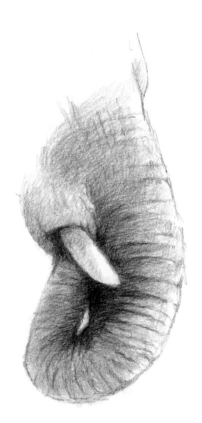

TUSKS

Only male Asian elephants have tusks, whereas both male and female African elephants have these continuously growing incisors. Tusks are made of dentine, like ordinary teeth, and are used mainly for digging or stripping bark from trees and, occasionally, as weapons.

Tusks often appear discoloured and rough textured from all the digging and scratching they do. Elephants often have irregularly shaped tusks, or one longer than the other. This is simply because one is worked harder than the other. Like a human's handedness, elephants can be right- or left-tusked.

Vic's tip

Up to a third of the tusk is out of sight inside the skull, and the visible part protrudes from under the top lip. To get an idea of what that looks like, try putting a pencil under your top lip, and seeing how it affects the shape of your lip.

1 The tusk itself is not a difficult shape to draw, but try to continue the shape back about another quarter, so that you can get an accurate curve of the top lip covering the base of the tusk. Give the tusk and surrounding skin area a subtle base colour, using Prussian blue and terracotta coloured pencils.

2 Use a burnt sienna coloured pencil to 'etch' in some scratches and other marks on the tusk. Finish off other details and shading with the black coloured pencil.

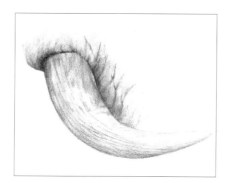

EYES

Elephants' eyes are quite small in relation to the size of their heads; the eye is roughly the size of a horse's eye. The eyes are located somewhere between the sides of the head and forward facing. The tear duct shape in the corner of the eye is non-functional, but still needs to be drawn.

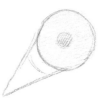

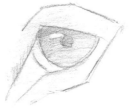

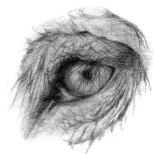

1 Begin by drawing a circle to represent the eyeball, with a round pupil sketched in the centre. Add the tear duct, ending up with a shape that resembles an ice cream cone.

2 Shade in the iris with a terracotta coloured pencil. Next, using simple lines, mark out the angle of the upper lid and folds of skin above and below the eye with a black coloured pencil. Mark out the position of the reflection in the eye, then add some basic colours: burnt sienna for a hint of shadow under the eyelid, Prussian blue and terracotta for the cool and warm tones in the elephant's skin.

3 Mark out some wrinkles and creases with the black coloured pencil, and, with the same pencil, add some soft shadows in the skin, as well as some darker shadows below the eyelid and deeper skin folds. A little pink carmine can be added in the corner of the eye and the top part of the lower lid. Finally, add a few long eyelashes from the upper eyelid, these will help protect the eye from dust and debris.

EARS

All elephants use their ears to help to cool them down, either by flapping them, or by pumping blood through the ears' veins, in much the same way as passing coolant through a car radiator.

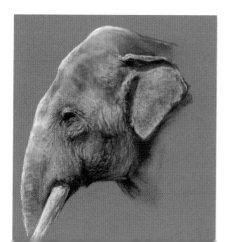

The picture on the left shows an Asian elephant, and the one on the right shows an African elephant, which has larger ears. Both sketches are in pastel on cork-impregnated paper, which helps in achieving a textured look to the skin. The paper in both cases is dark grey, which gives a solid background tone for the pastel colours – dark orange and sanguine, with black for details, folds and wrinkles and ivory for highlights.

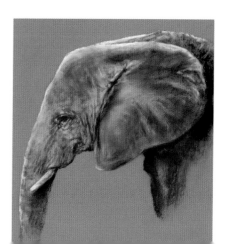

Other pachyderms

RHINOCEROS

The rhinoceros is, strictly speaking, an odd-toed ungulate, but rhinoceros were historically grouped with elephants as pachyderms. The name rhinoceros is derived from the Greek for 'nose horn'. Both familiar types of rhino have horns made from keratin, which is essentially hair, and, unfortunately, this feature has proved to be responsible for their endangered status.

Although there are Asian rhinos, most of us are more familiar with the larger African rhinoceros, of which there are two types; the black rhinoceros and the white rhinoceros. These two names can be confusing, as they are both basically the same grey colour. The term 'white rhino' is probably a misinterpretation of the Afrikaans word *wyd*, meaning square-lipped or wide, referring to the shape of its mouth use for grazing. The black rhinoceros was probably named to distinguish it from the 'white' rhinoceros, and its mouth is more pointed, almost like a flexible extension, for plucking leaves and twigs.

Despite the fact that rhinoceros have never been depicted in the same way as elephants in popular culture, there is still a fascination for these strange, prehistoric-looking animals.

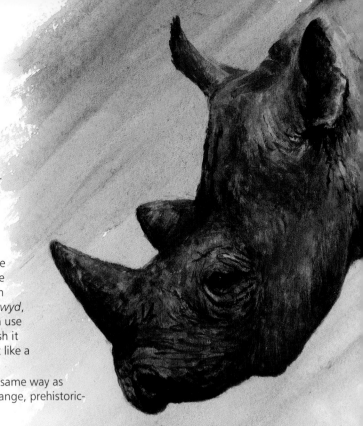

Similar and distinguishing features

Feet
Each of the rhinoceros' four feet has three toes, encased in very hard nails, to form hooves, similar to those of a giraffe.

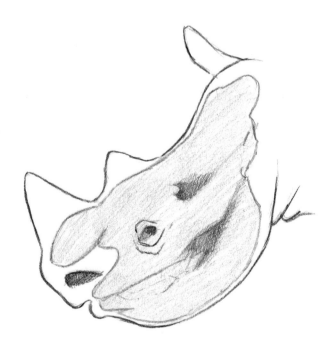

Vic's tip
For unusual shapes like our rhinoceros' head, try combining different-sized circles together. I find it much simpler to achieve the correct proportions this way, rather than trying to draw correctly sized irregular shapes.

Head shape and horns
Rhinoceros have a rather unusual head shape, with a very elongated jawbone. Here, I have sketched out the rhino's skull, shaded in brown, and added a black outline to show how it fits in to the rhinoceros' unusually shaped head. Notice that the horns do not form part of the rhinoceros' skull, as they are not made of bone. I painted the 'fleshed out' head with horns in acrylics, using burnt umber with burnt sienna washes (see top of page).

Rhinoceros in acrylics

1 Tone the whole canvas with a wash of burnt sienna over the pencil outline of the rhino – this will give the painting an overall warm tone, as well as sealing the drawing.

2 In this painting, I decided to focus on the strength of the rhino's shape: the distinctive head profile with its two horns, and the bulky, solid body. For that reason, I wanted the rhinoceros to be part silhouette, with strong highlights. Use transparent glazes of Payne's gray, Prussian blue and burnt umber to establish the darker tones and shadows.

3 Paint the highlights of the rhino's skin in increasingly thicker layers of burnt sienna, adding more yellow ochre and titanium white.

4 Apply the final white-yellow ochre highlights straight from the tube using a dry size 2 brush, and blend them in with your finger as the paint dries. This technique, along with the texture of the canvas board, helps to suggest thick, rough skin.

5 After protecting the rhino with masking tape and masking fluid, paint the background trees with thin burnt umber, followed by layers of transparent washes from burnt sienna, through yellow ochre, and finally titanium white.

Vic's tip

Paint the shadows using cool, transparent layers, especially when you are using a lot of warm colours in the painting.

The finished picture.

You will need

Canvas panel: 40 x 30cm (15¾ x 11¾in)
Acrylic paints: burnt sienna, burnt umber, Prussian blue, Payne's gray, yellow ochre, titanium white
Brushes: size 16 flat, size 8 flat, size 2 round

Basic shapes

The usual three egg shapes represent the three main parts of the body – chest and shoulder, midsection and hindquarters. The head is a little different here because of the rhino's unusual skull shape. Draw the main 'head circle' towards the front, as this is where the eye socket is, then place a smaller circle above that. The two circles together will give you the total head shape. The legs are short cylinders and the feet are half-domed shapes. The horns and ears are triangles. Finally, add the spine line to connect all of the shapes to give an accurate outline for the painting.

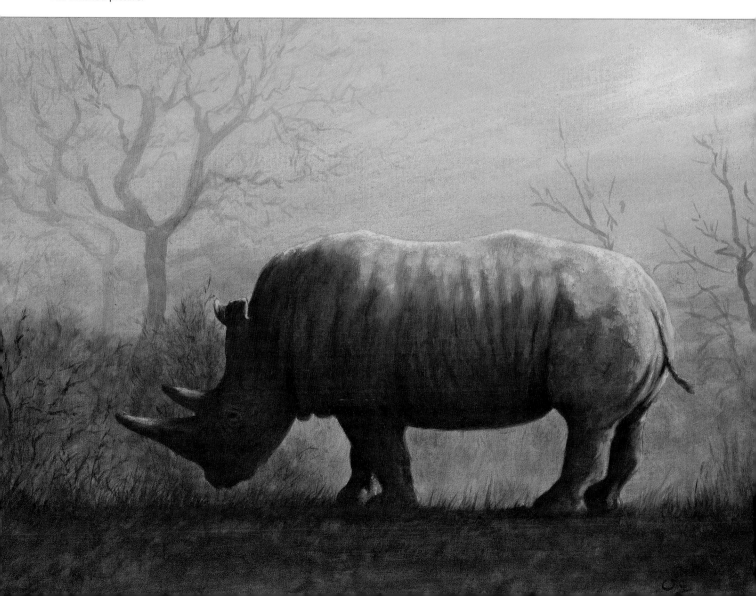

HIPPOPOTAMUS

The hippopotamus (*Hippopotamus amphibious*) is the second heaviest land mammal, after the elephant. The hippopotamus is a strange animal, in that it bears some resemblance to pigs, and also to elephants and rhinoceros, because of its thick skin and round, four-toed feet. Hippopotamuses are scientifically classed with other even-toed ungulates, such as camels. In fact, they are more closely related to whales in evolutionary history than they are to the rhinoceros or elephant.

Hippopotamuses are known to be one of the world's most dangerous mammals, and they kill more people in Africa each year than any other animal. Despite having short legs for its enormous bulk, and being semi-aquatic, a hippopotamus can easily outrun a human on dry land. Hippos also have very large mouths and canine teeth to match.

Despite their justified aggressive reputation, hippopotamuses have usually been portrayed as rather rotund, friendly, and even comical animals.

Similar and distinguishing features

Eyes
Because hippopotamuses spend so much time in the water, their eyes are located high on the skull, so that they can remain almost completely submerged to keep cool, and still see what is going on around it.

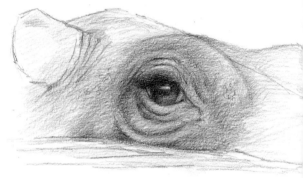

1 Draw one circle inside another, then add a dot in the centre of the smaller one as above. This first shape may seem a little strange, like a huge detached eyeball, but, in fact it represents the eyeball (small circle) within the large orbital (large circle) located on the upper part of the skull. The smaller dot is the position of the pupil.

2 Beginning close to the eyeball circle, draw in the upper and lower lid shapes, coming to a point in the tear duct, then sketch in some folds above and below the eye. Add in some basic colour, using Prussian blue and terracotta coloured pencils.

A little pink carmine coloured pencil was used here and there over the Prussian blue and terracotta to pick up the red skin tones. Final details and shading can be added using a black coloured pencil.

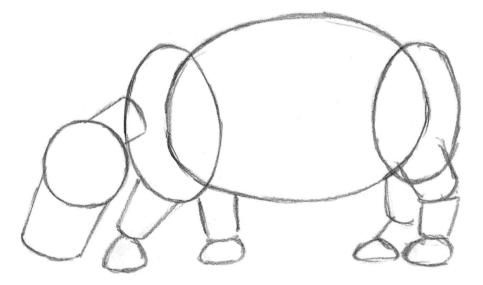

Skull and head
The basic body shapes of the hippopotamus differ only slightly from those of other animals that we have looked at so far. You can still use the three ovals for the body, cylinders for the legs and neck and small dome shapes for the feet. The skull of the hippopotamus differs quite a lot however, being more elongated. Rather than drawing an oval for the skull and risk getting the precise shape incorrect, I still prefer to begin with a circle for the skull, before adding a cylindrical shape for the snout.

Note how short the hippopotamus' legs are compared to an elephant's or rhinoceros' legs. This is because hippopotamuses spend so much time in the water and do not need their legs to bear as much weight.

Hippopotamus in watercolour

I was fortunate to photograph this hippopotamus just as it had broken the surface of the water and was 'giving us the eye', a classic hippopotamus pose.

1 After sketching the outline and features, use the size 8 flat to apply a wash of sap green to tone the water.

2 Do the same to tone the hippopotamus, using washes of burnt sienna and cobalt blue, the latter giving a nice shiny finish to the wet grey/pink skin, as well as providing a pleasing balance to the warm sienna, which reflects the red-brown coloured 'sun screen' pigmentation in the hippopotamus' skin.

3 Develop further tones with thin washes of Mars black over the sap green, cobalt blue and burnt sienna.

4 Use a wash of alizarin crimson to give a pink tone to the eyelid.

5 Add the final details using the size 2 round brush and Mars black.

You will need

300gsm (140lb) Not surface watercolour paper: 24 x 17cm (19½ x 6½in)
Watercolour paints: burnt sienna, cobalt blue, sap green, alizarin crimson, Mars black
Brushes: size 8 flat, size 2 round

Basic shapes

Instead of adding the usual 'spine line' over the basic body shapes, I have drawn the whole outline, to show the protrusion of the eye socket, and also the thickness of the neck, which is mostly fat.

The finished picture.

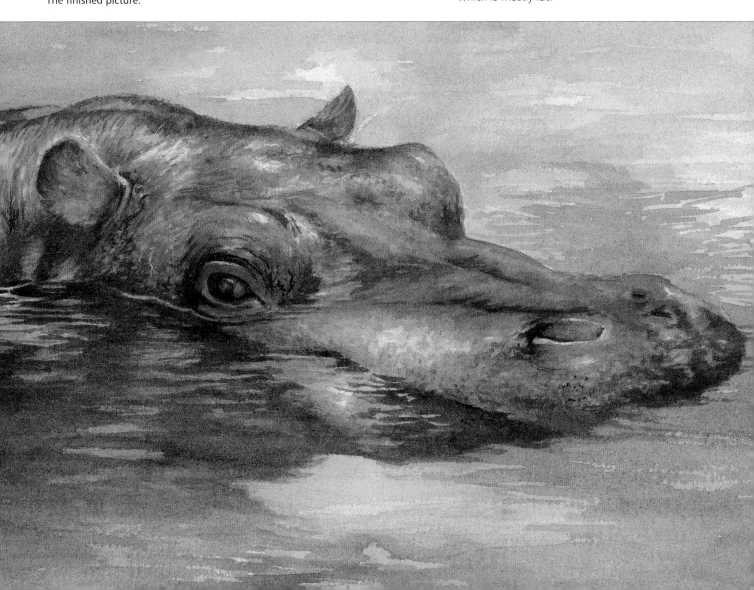

Asian Elephant

Elephants have thick, textured skin, and it can sometimes be difficult to portray this in a painting or drawing. Using a sanded paper is a good place to begin achieving the textured appearance of their hide. Combine this paper with an acrylic underpainting to establish the basic colour, and add pastels to enhance the texture still further.

Asian elephants have a lot of character in their faces, which is why I chose to paint a close, cropped portrait (see page 31). They also have quite 'spotted' skin, which means you can have lots of fun spattering paint with your old toothbrush.

You will need

450gsm (210lb) fine-toothed
 sanded acrylic paper, 30 x 23cm
 (11¾ x 9in)
Acrylic paints: burnt sienna,
 burnt umber
Hard pastels: black, sanguine, ivory
Soft pastel: yellow ochre
Brushes: 15mm (½in) short flat
Masking tape and drawing board
2B pencil
Old toothbrush

1 Secure your paper to the drawing board with low-tack masking tape. Use a 2B pencil to sketch out the basic image of the elephant.

2 Dilute burnt sienna acrylic to the consistency of single cream and block in the elephant's head using a 15mm (½in) short flat.

3 Once the paint is completely dry, dilute the burnt sienna further and tone the background with a very faint wash. Apply the paint loosely with the 15mm (½in) short flat.

4 Take the board off the easel and lay it flat, then pick up slightly diluted burnt umber on an old toothbrush. Hold it 15cm (6in) or so away from the paper and draw your thumb over it repeatedly to spatter the painting, concentrating on the elephant's skin. Once the paint has dried completely, replace the board on the easel.

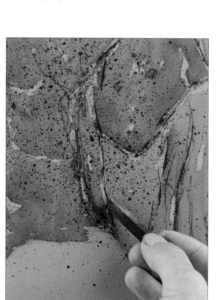

5 Use the corner of a black hard pastel to establish the main outlines, wrinkles and features on the neck and ear.

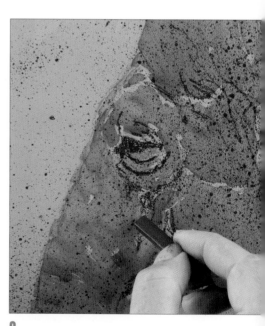

6 With a firm grasp on the pastel to ensure control, establish the elephant's eye.

Vic's tip

Hold the pastel loosely at the very end for less control. This is useful for ensuring your marks are uncontrived.

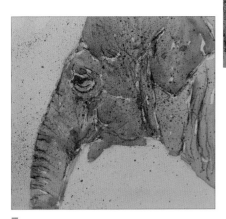

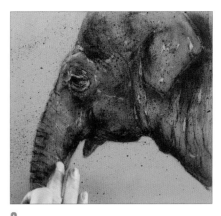

7 Continue to block in the dark outlines of the elephant with the black hard pastel.

8 Use the side of the black hard pastel to establish the areas of shadow behind the ear (see inset), then blend the shadow in using a clean finger.

9 Use the black hard pastel to build up areas of shadow under the neck, mouth, cheekbone, eye socket, brow ridge and trunk, then blend in the colour with your finger.

10 Pick out some warm highlights around the eye using the sanguine hard pastel. Use the corner to apply smaller areas, and smudge it in for larger areas or a softer effect.

11 Build up subtle warm highlights across the rest of the elephant in the same way.

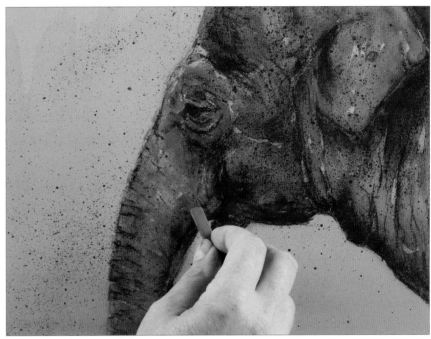

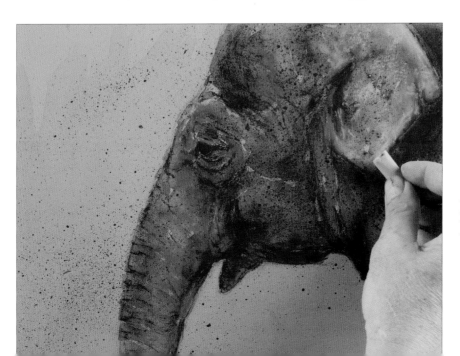

12 Switch to the yellow ochre soft pastel and add highlights to the ear, using the sharp edge and the side for the harder edges (softening them in with your finger) and the side to add texture to flatter surfaces.

91

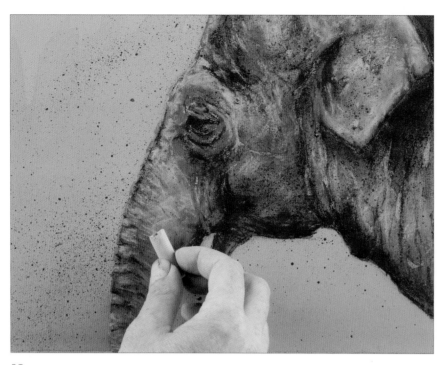

13 Use the yellow ochre soft pastel to add soft highlights across the skin.

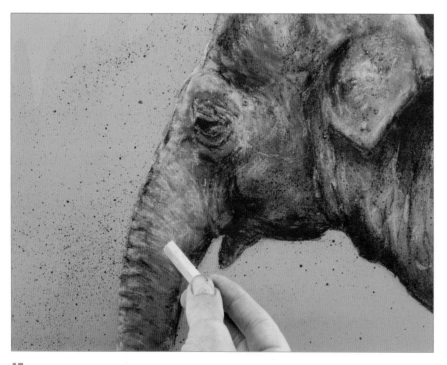

14 Switch to an ivory hard pastel for the strongest highlights, applying them sparingly over the softer yellow ochre highlights around the brow and eye area, in order to draw attention to the eye itself.

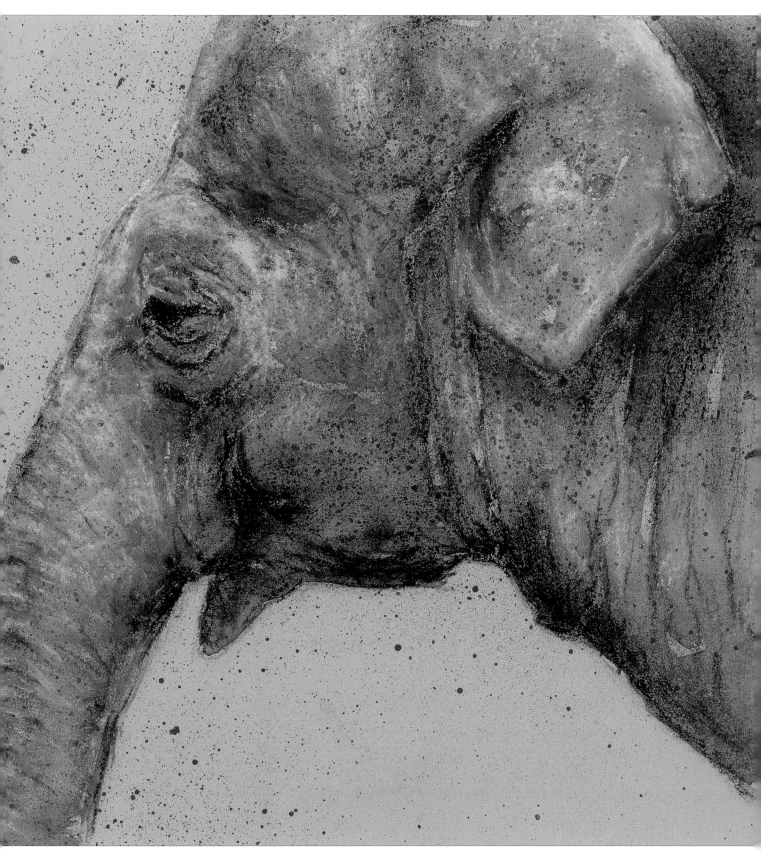

The finished picture.

Great apes

The family of great apes, *Homindae*, includes our closest non-human relatives; gorillas, chimpanzees, bonobos and orangutans, and it is to this family that we also belong: all of us are large, tailless primates. As a zoological family, it is thought that we share more than ninety-seven per cent of our DNA.

Despite the fact that relatively few of us have actually had close contact with our primate cousins, we seem to have a close affinity with apes, even to the point of 'humanising' them in film and television. In popular fiction, television and cinema, the chimpanzee has mostly been portrayed as man's intelligent and often comic companion – consider Tarzan and Cheetah for example. Conversely, gorillas were usually seen as terrifying monsters – often extremely oversized – like King Kong carrying off Hollywood starlets.

The common chimpanzee (*pan troglodytes*) is our closest living relative, with up to ninety-nine per cent shared DNA. Although we often perceive them as cute, comical animals, chimps can be very aggressive as adults, and have very powerful long arms. The chimp's strong arms are ideal for climbing trees, but are just as capable of tearing monkeys and other animals apart.

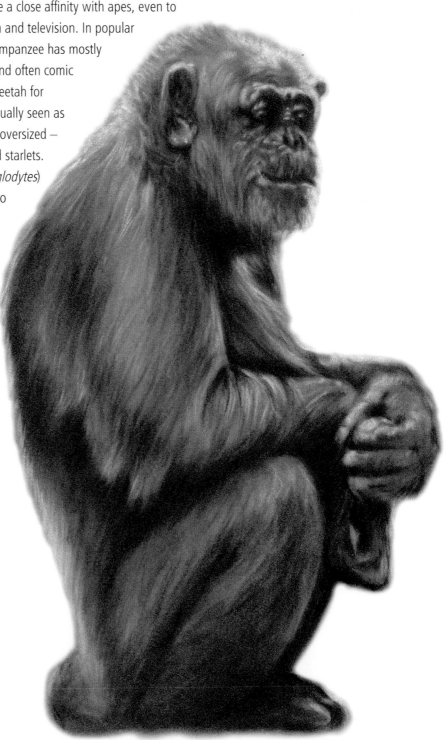

Basic shapes

The construction of body shapes for the pastel sketch opposite is relatively simple to do. The head, especially, is very human-like, although chimpanzee ears are generally bigger and the tops slightly higher in comparison with a human. The mouth area is larger and rounder, so I have used an oval shape under the nose to position this. In a human head, the eyeline would be halfway down the circle, but in this case it is about one-third down, as the chimp has a flatter skull shape than that of a human, the nose line being in the middle.

I have also drawn in the spine line to connect the large chest shape with the oval thigh shape. Note the large cylinders and ovals representing the muscular upper arm and thigh.

For the most part, chimps walk on all fours using their knuckles (knuckle walking), but because they have broad feet with short toes, chimps can also walk upright when needed. Below is shown an example of the position of the three oval body shapes when the chimpanzee is in a knuckle-walking posture. Again, I have added the spine line to show how it connects the three main body sections.

Note the length of the arms compared with the legs. When outstretched, the arms are approximately one and a half times the height of the body.

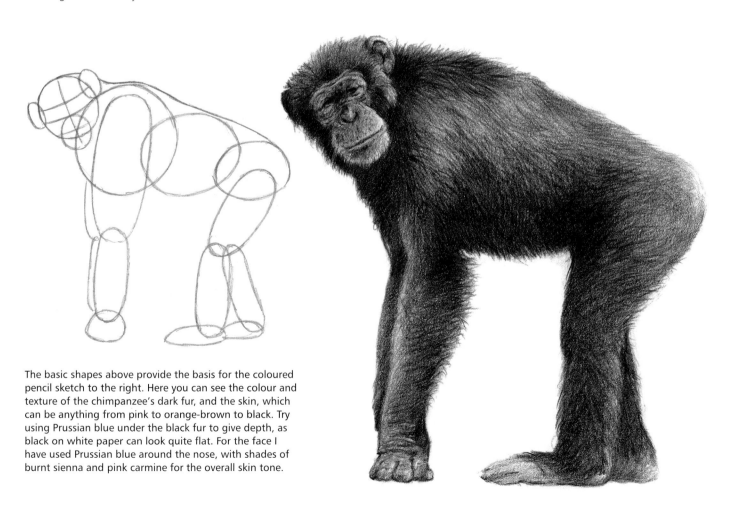

The basic shapes above provide the basis for the coloured pencil sketch to the right. Here you can see the colour and texture of the chimpanzee's dark fur, and the skin, which can be anything from pink to orange-brown to black. Try using Prussian blue under the black fur to give depth, as black on white paper can look quite flat. For the face I have used Prussian blue around the nose, with shades of burnt sienna and pink carmine for the overall skin tone.

Distinctive features

EYES

Apes' eyes are forward facing, with binocular vision like our own; they are also deep set, beneath a protruding brow. Like humans, apes convey emotion with their eyes, as well as other facial expressions. All apes – indeed most primates – have a dark-coloured sclera (the part of a human eye that is white). As usual when drawing eyes, begin with basic circles.

 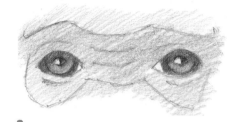

1 Draw the eyeballs as two circles, with the inner circle representing the iris. Sketch the round pupils in the centre.

2 Shape the eyes with upper and lower lids; this shape is very similar to that of human eyes. Colour the iris with a terracotta coloured pencil and the sclera with burnt sienna over pink carmine. It is helpful to leave a white area for the highlight at this stage.

3 Use Prussian blue to create a mask shape above the brow and beneath the eyes, and terracotta across the brow between the eyes. Add some shadow beneath the upper lids with a burnt sienna coloured pencil.

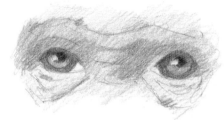

4 Begin to shade the recessed areas around the chimpanzee's eyes with the burnt sienna coloured pencil, adding a hint of the wrinkles below the eyes with the same colour.

5 Add the final details and darker shadows using a black coloured pencil. Keep the pencil sharp for the fine wrinkles around the eyes. Use the black to add more shadow beneath the upper lids and below the brow to ensure the chimp's eyes are really set back.

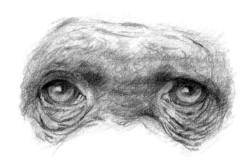

NOSES AND MOUTHS

Like ours, apes' noses have slanted nostrils separated by a narrow septum (cartilage between the nostrils). The main difference between human and ape noses is that the latter are very flat.

Apes have a more protruding upper and lower jaw than humans, so their lips are larger to cover this area. Chimpanzees' lips stretch in all directions and lip curls, baring teeth and other expressions that use the lips are all important communication methods. All that stretching contributes a lot to the mass of wrinkles in the skin of the upper lips in particular. Let's look at how to draw the chimp's nose and mouth combined.

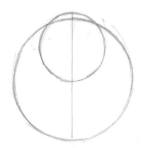 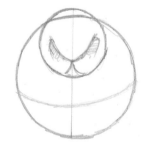 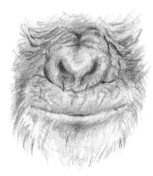

1 Begin with a circle for the general mouth area, which includes the top lip, bottom lip and chin. Then add a smaller circle at the top for the chimp's flat nose. It is always useful to draw a vertical line through the centre of the circles; this helps to centre the middle of the nose (septum) with everything else.

2 In the next stage, draw in the slanted shape of the nostrils and the septum where it joins the top lip. Add a curve for the line between upper and lower lips.

3 Now you can begin to sketch in more accurate shapes and lines for the general nose and mouth area, adding some hairs around the lips. Add some basic background colour, using Prussian blue, terracotta and pink carmine coloured pencils.

4 Add final details and texture with burnt sienna and black coloured pencils. Use the Prussian blue and terracotta to create more subtle shading, and there will be your finished chimp's nose and mouth.

HANDS AND FEET

Although most of us do not walk on our knuckles, we do share an important feature with our ape cousins – we all have opposable thumbs, giving us the ability to grasp objects. Other apes, especially chimps, use this feature to fashion and use rudimentary tools. They use these for numerous tasks such as extracting termites from logs. Apes also have opposable big toes, which help the feet to hold on to branches.

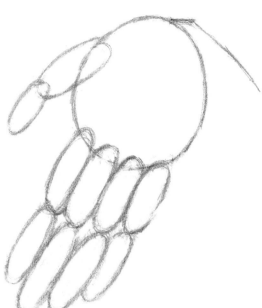

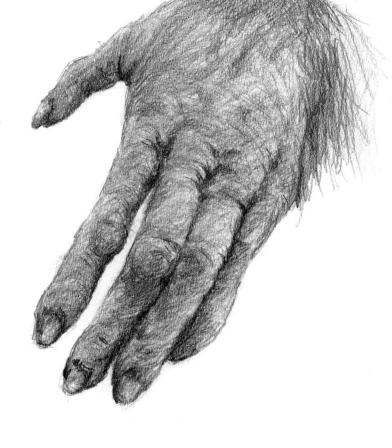

Here are the basic shapes for drawing a chimpanzee's hand (above), and the finished chimp's hand in coloured pencils: terracotta, Prussian blue, pink carmine and black (right). Note the slender fingers and wrinkly skin, very much like an older person's hand.

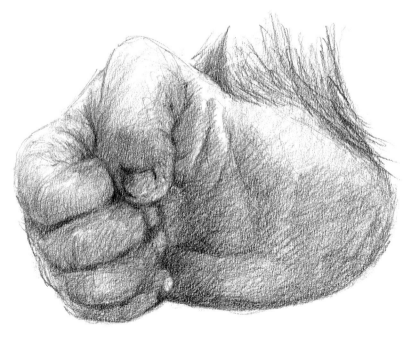

These are the basic shapes for drawing the chimp's grasping foot (left), and the finished coloured pencil sketch (right). This picture shows the opposable toe, which enables the chimpanzee to grasp with its feet.

Other apes

GORILLA

Although nowhere near the size of King Kong and other monstrous apes from popular fiction, the gorilla is the largest of all the great apes. Male silverback gorillas are the heaviest and most muscular of all. Gorillas inhabit forested and mountainous areas, and have become endangered through loss of habitat, poaching, and civil war in the countries in which they live. The western lowland gorilla lives in forests and swamps in central and West Africa, while the mountain gorilla inhabits the mountainous region of the Congo.

Once thought to be violent creatures, we now know that gorillas are very social, peaceful and even gentle animals that do not deserve their 'movie monster' reputation. Although they are capable of standing and even walking a little on their hind legs, gorillas, like chimps, are knuckle walkers.

Gorilla in pastels

Painting or drawing animals with dark fur can be daunting; how can you create masses of dark hair without painstakingly rendering each one, layer upon layer?

Using a dark support, like the grey paper here, will help in rendering dark tones. Think about underlying colours; black fur, as with our gorilla here, always shines with either blue or brown hues. The gorilla in this contemplative portrait is a western lowland gorilla, which are known for the red-brown crests on top of their heads.

1 After sketching and laying down some tonal values with the black soft pastel, almost like a charcoal sketch, apply flat colour with the side of a Prussian blue soft pastel over the body, face and hand. This will give the gorilla's fur a blueish sheen when the sketch is completed. Do the same around the top of his head with the side of a sanguine pastel.

2 Much of the detail in this portrait is implied with strong tonal shaping. Use the side of the black pastel over the coloured tonal sketch to create rounded forms in the head, face, back and powerful shoulders.

3 When applying details, remember that the extreme tones, black and white, will be the most visible; so use black and white soft pastels to create some sharper facial features and details in the hand with strong shadows and crisp highlights.

4 Finally I used the cadmium orange with a little of the ivory soft pastel over it to indicate light catching the top of the gorilla's crest to help lift him off the grey background.

You will need
Dark grey velour paper: 25 x 35cm (9¾ x 13¾in)
Soft pastels: black, Prussian blue, white
Hard pastels: sanguine, white, cadmium orange, ivory

Basic shapes
As with other great apes, using two circles for the head gives the extended heavy jaw. Note the angles used to create the crest and profile of the brow.

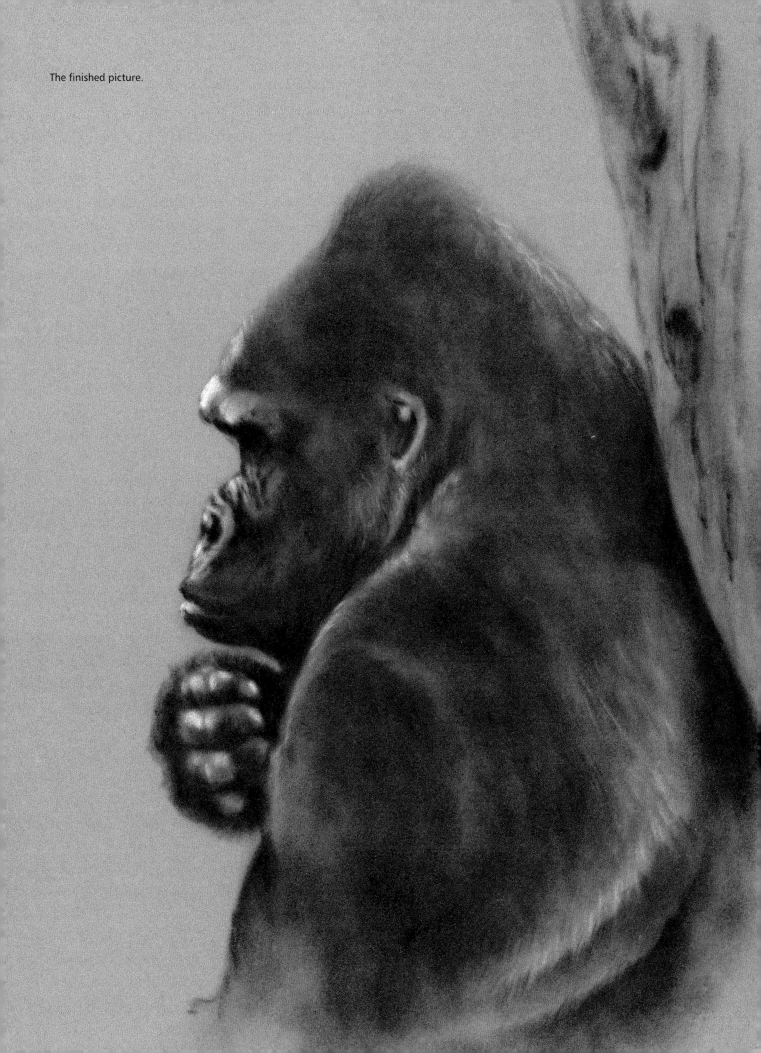

The finished picture.

ORANGUTAN

The most obvious difference between orangutans and other great apes is their fur, which is long, shaggy and a deep red-orange colour. Many of us seem to identify particularly with orangutans, as they have so many 'human' qualities. Orangutans are highly intelligent animals, and are adept at making tools for tasks such as digging and prodding. Some even make umbrellas from large leaves to shelter from the rain. They have almost human-like faces with gentle, expressive eyes. It is not surprising that the Malay word 'orangutan' means 'man' (orang) 'of the forest' (hutan).

As orangutans spend much of their lives in trees, they have much longer arms than the other great apes, about twice as long as their legs. They also have very flexible hip joints, so are capable of striking some wonderful poses.

Similar and distinguishing features
Curved fingers

Orangutans' fingers and toes are curved, with low-set opposable thumbs and big toes, to enable them to hold on to branches.

Hands can be quite complicated to draw, so here I have again broken the hand down into ovals and cylinders, which really helps, especially when drawing a grasping hand.

You can see how the basic shapes have helped to achieve the correct shapes for the curved fingers in this coloured pencil sketch.

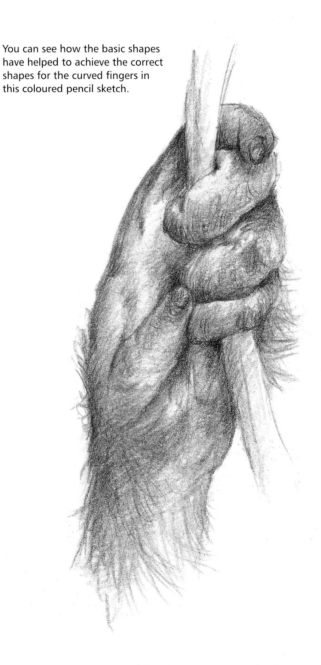

Orangutan in pastels

I have used olive green paper for this project, as it gives a visually striking contrast to the orangutan's red-brown fur. In addition, this colour suggests the forest environment in which the orangutan lives. Sanded pastel papers are perfect for attaining rich colours in a sketch like this, without the need for very fine details.

1 After sketching in the subject, add the darker tones using the hard black pastel.

2 Move on to the midtones with the sanguine hard pastel. Begin to add texture and some details in the long shaggy fur, rubbing and smoothing the pastel here and there with fingers and a blending tool.

3 Add some textured midtones to the face with the blue-grey pastel.

4 Create highlights in the fur and face using the cadmium orange hard pastel, before completing the sketch by adding occasional highlights in the orangutan's face using the ivory hard pastel.

You will need

Olive-green sanded pastel paper: 23 x 30cm (9 x 11¾in)
Hard pastels: black, sanguine, blue-grey, cadmium orange, ivory

Basic shapes

Here are the basic shapes for the orangutan pastel sketch. Note the use of two circles for the head and mouth area, and long cylinder shapes for the orangutan's very long arms.

The finished picture.

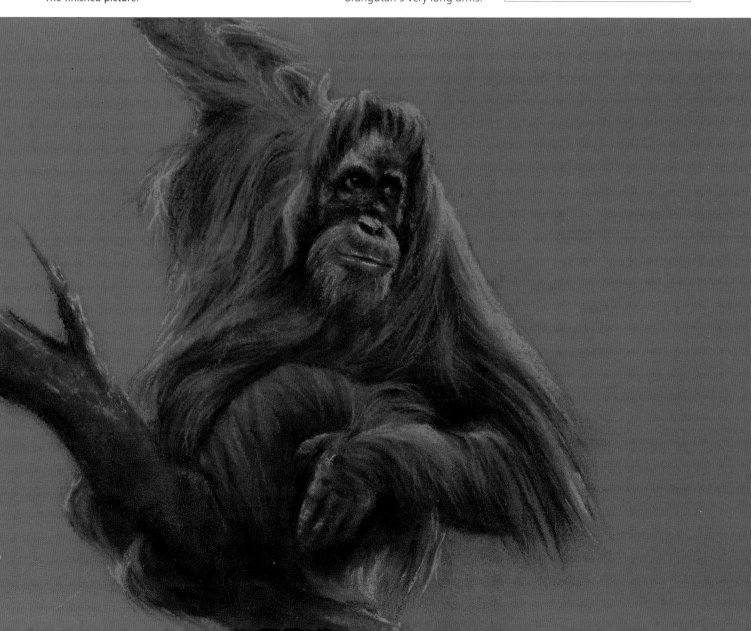

Chimpanzee

I think it is important to try and establish character in the expression when painting a portrait. An animal portrait is not just a head study of a particular species, but an attempt to capture a particular animal's personality and spirit. I photographed this particular chimpanzee a few years ago, and it seemed to have an almost soulful expression. Sadly, the photograph was quite poor quality – there were no sharp details and it was overexposed.

This turned out to be a blessing in disguise, as it gave me the idea of creating an atmospheric portrait, where fine details are not as important as tone, colour and lighting. A few coloured pastels and black velour seemed the perfect choice in this case.

You will need
260gsm (120lb) black velour paper:
　35 x 25cm (13¾ x 9¾in)
Hard pastels: white, sanguine, ivory
　and black
Soft pastels: Prussian blue,
　sanguine, blue-grey and orange
Low-tack masking tape
Drawing board
White watercolour pencil

1 Secure the black velour to your drawing board with low-tack masking tape and sketch the initial drawing of the chimpanzee using a white watercolour pencil.

2 Use a hard white pastel to develop the lines of the initial sketch near the eye on the left-hand side. Apply the pastel fairly lightly by holding the stick towards the back. Work a small area, then gently brush the lines with a clean finger (see inset) to encourage the pastel to settle into the velour.

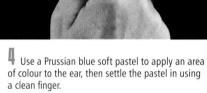

4 Use a Prussian blue soft pastel to apply an area of colour to the ear, then settle the pastel in using a clean finger.

3 Work round the rest of the sketch in the same way to add a little more detail and suggest the main areas of highlight. Work gradually, adding pastel to small areas, then settling them with a clean finger before moving on.

Vic's tip

Do not worry about minor errors. They can be corrected with black pastel later.

5 Add more blue areas as shown to serve as cool highlights, then settle them in.

6 Use a sanguine soft pastel to build up warm highlights around the chimp's lips, and settle them in with a clean finger.

7 Build up and settle warm highlights with the sanguine soft pastel. These highlights represent light coming from behind the chimpanzee's head, so create a slight halo outline effect at the top of the head.

8 Switch to a blue-grey soft pastel and use slightly more controlled strokes to begin to develop the detail on the brows and ears.

9 Build up the detailed neutral highlights in small areas. Use more pressure for choppier, more striking areas, and make smaller, lighter marks for softer highlights, such as on the nose.

10 Switch to an orange soft pastel and heighten the highlights on the warm areas. Use the edge to develop sharper texture with short touches.

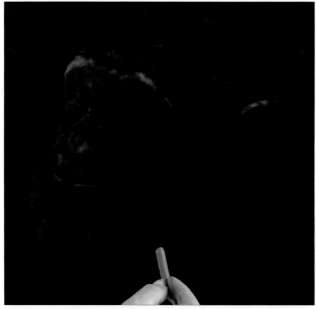

11 Use a sanguine hard pastel to build up a wrinkly skin texture on the brows.

12 Develop the texture on the warm areas using the sanguine hard pastel. Vary the touch you use: dabbing the stick softly on to the surface for skin, and using longer, but still very light, strokes for the hair.

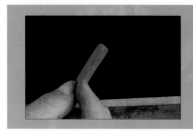

Vic's tip

For longer hairs, hold the pastel right at the very end, so that you can barely grip it. Touch it to the surface, then draw your hand down, allowing the pastel to draw a loose, very fine line.

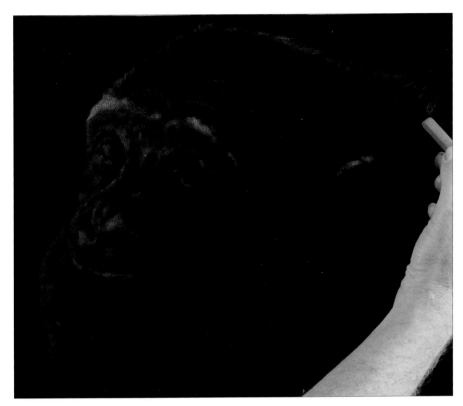

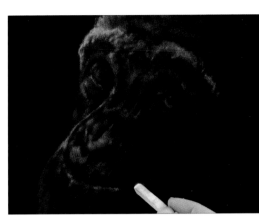

14 Use an ivory hard pastel to overlay parts of the highlights and create the brightest, most extreme highlights around the nose and brow area.

13 Develop the backlit hair on the top of the chimpanzee's head to frame the outline and bring it forward from the black background of the surface.

15 Use a white hard pastel to touch in some hard reflections on the eyes. Do not settle them in, so that they remain bright.

16 Use a black hard pastel to reinstate the extreme dark areas around the mouth, nostrils and eyes.

17 Reinforce the red areas with additional touches and short strokes of the sanguine hard pastel.

18 Tidy up any hard lines of the original sketch by overlaying them with a black hard pastel.

Vic's tip
You can use the sticky side of low-tack masking tape to pick up stray pastel dust or other debris from velour.

The finished picture.

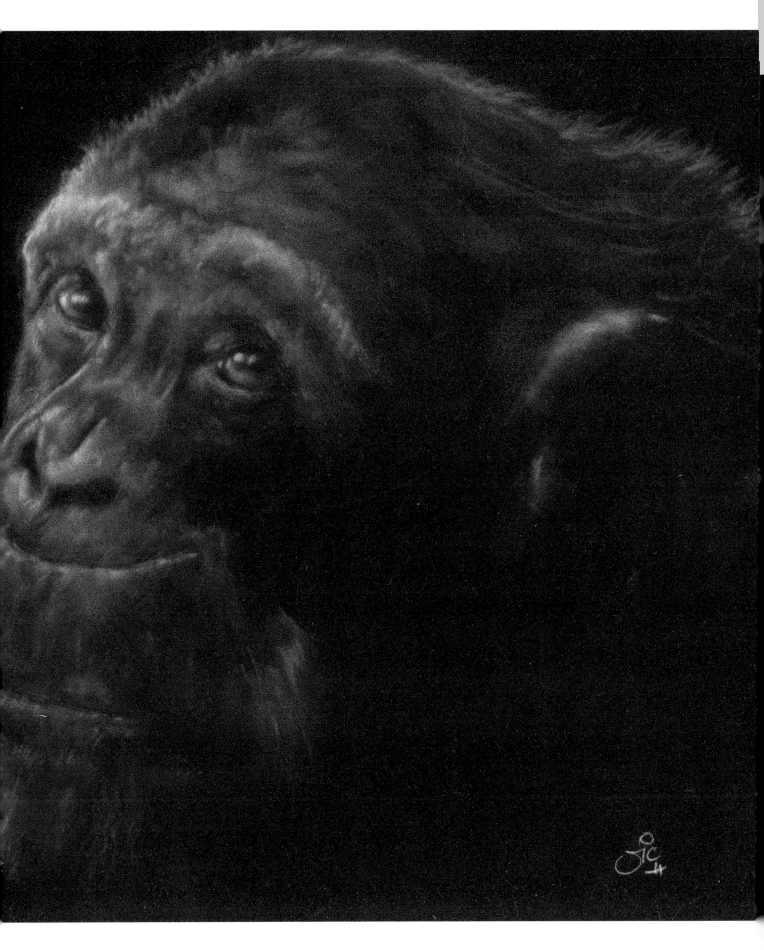

Canids

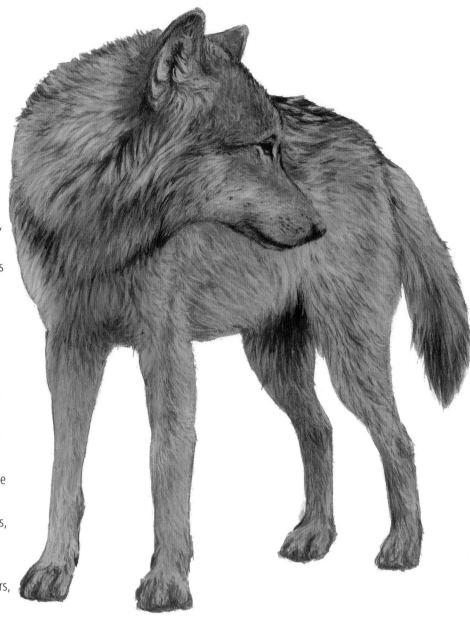

Canids are carnivorous mammals such as wolves, foxes, jackals and, yes, even our very own domestic dog.

Canids are split into two tribes (a biological classification between family and genus): *canini*, which includes wolves, coyotes, African hunting dogs, jackals and domestic dogs; and *vulpini*, which includes red foxes, grey foxes, desert foxes and Arctic foxes.

With the exception of Antarctica, wild canids can be found all over the planet, and most of them have broadly similar physiques: lean bodies with relatively long legs, a form ideal for hunting.

Like cats, canids are digitigrade, walking on their toes rather than the flats of their feet. Unlike most cats however, canids have non-retractible claws; as the claws are needed for grip when chasing prey animals, much like the cheetah. Most canids hunt in packs, and therefore have developed strong social bonds with designated leaders, commonly known as 'alpha' animals.

Probably the most famous member of the wild canid family is the grey wolf (*canis lupus*). The wolf's infamy, dating back hundreds of years, is well documented, if somewhat ill-deserved. I have a great fondness for wolves, and part of my work as an artist involves fundraising for conservation and education. Most of us grow up believing that we know wolves from popular fairy tales and cartoons such as *Little Red Riding Hood* or *The Three Little Pigs*, where the wolf is portrayed as a wicked or evil adversary. Legends of lycanthropy, where humans turn into wolves under the full moon and kill people are too numerous to mention. I find it strange that humans have regarded wolves in this way, given that the domestic dog, with whom we have a much more loving relationship, is a direct descendant of the grey wolf.

Basic shapes

Using the by now familiar geometrical shape method, we can construct the basic shapes for the wolf painting opposite using circles, ovals, cylinders and triangles (see right), even though the pose and angle of his head may seem problematic at first.

Like our own domestic dogs, wolves spend a lot of time lying down, especially under the shade of a tree in the heat of the day, or curled up in a ball to keep warm in winter. This is a pose that most of us who have pet dogs will recognise, and it is not too difficult to draw.

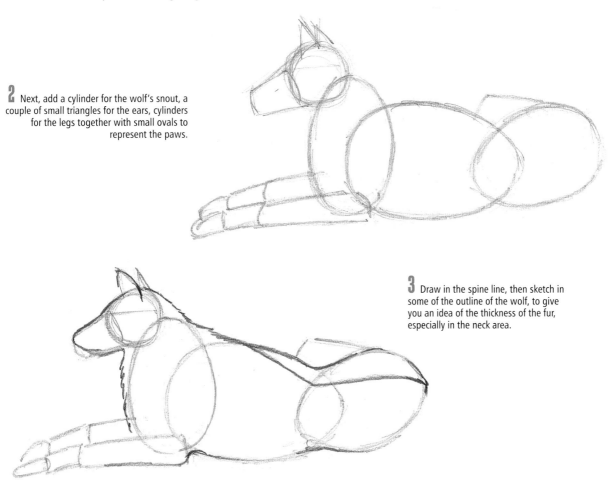

1 Begin with a circle for the head then add the three ovals. The oval representing the chest is upright, the one for the mid-section is horizontal, and the oval for the hindquarters is at a slight angle.

2 Next, add a cylinder for the wolf's snout, a couple of small triangles for the ears, cylinders for the legs together with small ovals to represent the paws.

3 Draw in the spine line, then sketch in some of the outline of the wolf, to give you an idea of the thickness of the fur, especially in the neck area.

Distinctive features

EYES

Wolves have piercing eyes. Very little of this almost primaeval look remains in the eyes of domestic dogs, which have evolved to have soft brown eyes to make them more appealing to humans.

The eyelids and rims give the eyes an almond shape, which is thought to help protect them from icy winds, much like Siberian huskies. Wolves' eyes appear in different colours, from yellow, to greenish yellow and amber. The eyes are only blue in wolf pups, and certainly never red, except in horror movies!

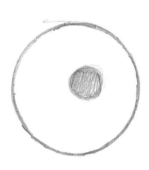

1 Begin by drawing a circle to represent the eyeball, with a round pupil towards the right-hand side; this wolf will be looking to our right.

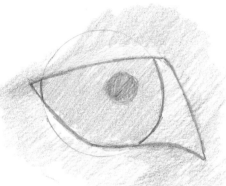

2 Next, create the almond shape by sketching in the upper lids and lower rims, forming a point in the tear duct, then use, in this case, a Naples yellow coloured pencil as the base colour for the iris. Add some colour to the surrounding area with terracotta and Prussian blue coloured pencils.

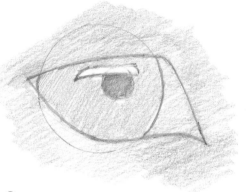

3 Assuming that the light source is coming from above, there will be a reflection of the sky in the upper part of the eye. You can sketch this in as a basic shape, erasing the yellow from this area. Remember to leave a little room above the reflection for the shadow under the upper lid, which is cast by the light from above.

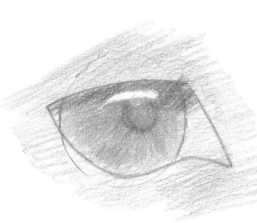

4 Add some flecking in the iris with a terracotta coloured pencil, leaving a slightly lighter yellow towards the bottom, before shading above the reflection with a burnt sienna coloured pencil.

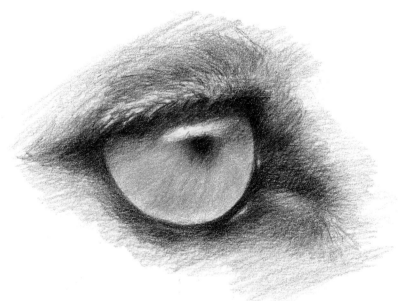

5 Now you can finish the final details and shading with a black coloured pencil, and a little mauve in the tear duct area to push that shaded area further back.

PAWS

Wolves' paws are like human hands and feet: people either love or hate drawing them. I personally love drawing and painting paws of all kinds; and it need not be difficult, especially when you apply some simple shapes to help you.

Wolves have large webbed paws, which act a little like snow shoes, preventing them from sinking into deep snow. They also enable them to swim quite effectively. There are five toes on the front feet – including the dew claw, which is roughly in the same position as the human thumb – and four on the back. In fact in the illustration to the right the wolf's paw looks very much like an elongated hand, and it is roughly the same size as an adult human hand. The exercise below shows how to draw the wolf's two front paws together. This is so that you can see the angle and spread of the paws; how they splay outwards.

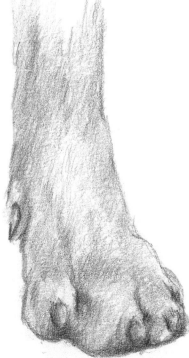

 1 Draw two vertical cylinders for the lower legs. The feet are large ovals, with the toes represented by drawing smaller ovals.

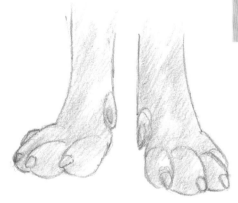

Vic's tip

Note how narrow the cylinders for the legs are compared to the size of the feet. Wolves have longer legs and much larger feet – both proportionally and physically – than the average domestic dog.

2 Next, add the claws to the ends of the toes. Note that the wolf's claws are not sharp that those of a cat, with the exception of the dew claws, as they are constantly being worn on the ground; this is because they are permanently protracted. Add some base colour at this stage, using a burnt sienna coloured pencil, with Prussian blue for the claws and shadow areas.

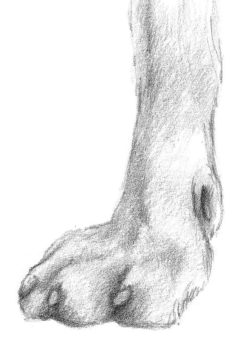

3 Final details and shading can now be added to complete the paws, using a black coloured pencil.

NOSES

Of all the wolf's senses, its sense of smell is by far the most acute. A wolf can pick up the scent of an animal over a mile away, and can pick up the scent from that animal's location three days after it has left.

First of all, let's look at how to draw a wolf's nose head on, without having to consider awkward angles. As always, the nose becomes much easier to draw correctly if we can break it down into simple shapes.

Vic's tip

Wolves' noses, like those of most domestic dogs, are black, moist and cool. Strangely enough, something you should try to avoid when painting a black canid nose is painting it black! There is nothing more distracting in a beautifully rendered wolf painting, than to see a solid black nose with a shiny highlight that looks as if it has been added as an afterthought: this is fine for cartoons, but not for realistic paintings. Using a Prussian blue as the background tone for the nose will give your black depth, and it will automatically suggest coolness.

1 We have already seen how a cat's nose can be represented by a triangle; and a wolf's nose can be simplified in the same way to a shape like a teacup without the handle. Begin by drawing a teacup as if looking slightly inside from above. Next, draw a curved line around the middle of the cup, and then a vertical line through the centre; this will line the nose up with the cleft in the wolf's upper lip.

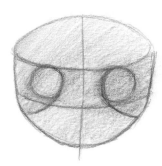

2 Now we can draw the nostrils within the upper half of the teacup face, confident that they will be the correct size and placement. First of all, draw two circles with roughly a circle's width between them. Then add a 'tail' facing outwards to each circle, giving a result like back-to-back quotation marks. Add a base colour of Prussian blue coloured pencil to help with the cold nose effect.

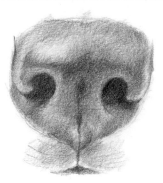

3 Use a sharp black coloured pencil to shade inside the nostrils and draw the sides and centre line of the nose more accurately. With the side of the black pencil, cast the remaining shadows lightly, so that the blue shows through the black. Note that the highlight on the left of the nose is now a soft pale blue compared to the rest of the blue-black nose.

Three-quarter view

This is probably the most common view when photographing or painting animal portraits. The good news is that the basic shape is still a teacup, only slightly tilted according to the angle you want.

Vic's tip

Remember that, as an artist, you do not have to rigidly stick to colours and tones that you see in reference photographs. If a nose looks black in the photograph, use your skills to give it more depth and life in your painting.

1 Draw a teacup shape at a slight angle. When drawing in the vertical line, make sure that it is off-centre, depending on which way the wolf is facing.

2 This is the only really tricky part of drawing the nose on an angle. The 'speech marks' that we used in the head on view, are now either squashed (far side) or stretched (near side); but, with a little practice and observation, you should easily manage these otherwise difficult shapes. Again, an undercoat of Prussian blue is needed before the black.

3 As before, render final details and shading with the black coloured pencil. Remember to keep the pencil sharp, or you will lose the intensity of tone. Again, the highlight is not too strong, having a faint touch of blue in it.

FUR MAPS

As always, in order to achieve a realistic drawing or painting of an animal, it is important to accurately depict the fur of that animal. The thickness and texture of a wolf's fur changes with the seasons. It is much thicker with a dense undercoat in the winter, and in summer the coat is closer and smoother. The wolf's fur pattern – the direction in which the hairs grow – remains the same, regardless of the season.

To the right is shown the fur pattern in the wolf's head and face. Note that the main difference between the canine and feline fur patterns (see page 37) is the direction of the fur between the tip of the nose and the eyes. On cats (big or small) the fur grows down the nose from between the eyes, whereas on canids (both wild and domestic), the fur grows up from the tip of the nose.

At the bottom of the page you can see the pattern of fur on the wolf's body from the top of the head to the bushy tail. Wolves have a dense undercoat of soft grey fur, and an outer layer of oily straight guard hairs for weatherproofing. These outer hairs are particularly prominent along the back, from the shoulders to the tail.

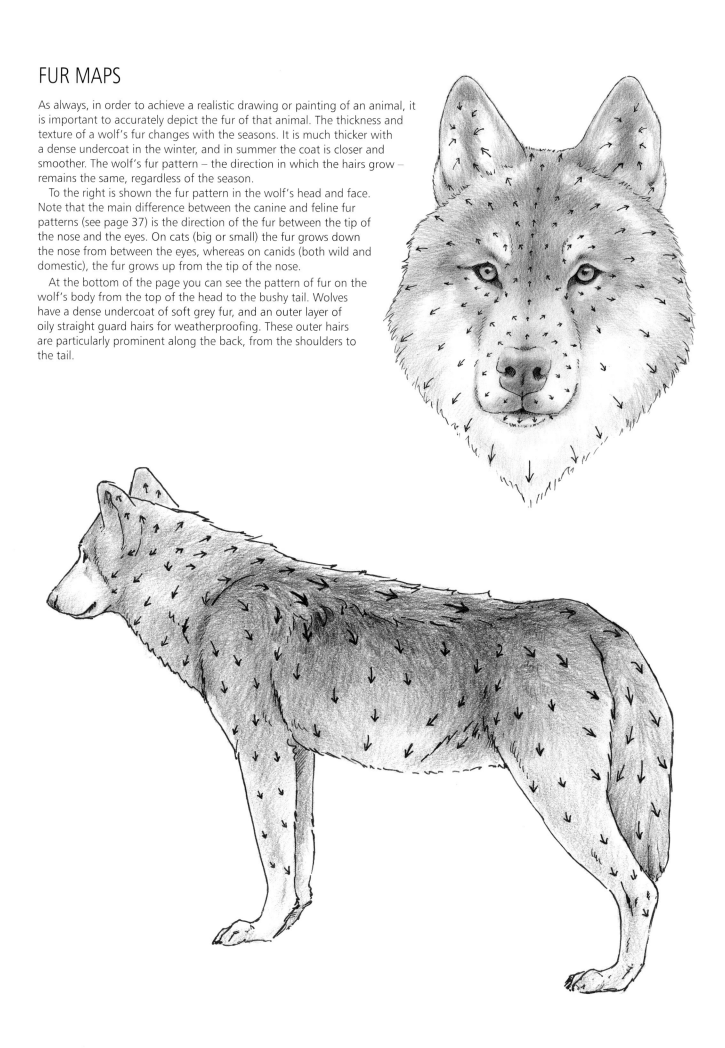

Other canids

DESERT FOX

The kit fox (*Vulpes macrotis*) is the smallest group of canids in North America, about the size of a large domestic cat. Because kit foxes tend to inhabit desert or semi-arid regions, these pretty and very delicate-looking animals are generally referred to as 'desert foxes'.

Desert foxes have dense, sandy to grey coats to help blend into their environment. They are mostly nocturnal animals, preferring to hunt in the coolness of the desert night. They also have very large ears, which help to dissipate heat from their bodies. They can survive on very little water, obtaining what moisture they need from plants, berries, insects and small prey animals.

Notice how large the triangular-shaped ears are in relation to the rest of the fox. The fox's tail is roughly half the length of its body.

Similar and distinguishing features

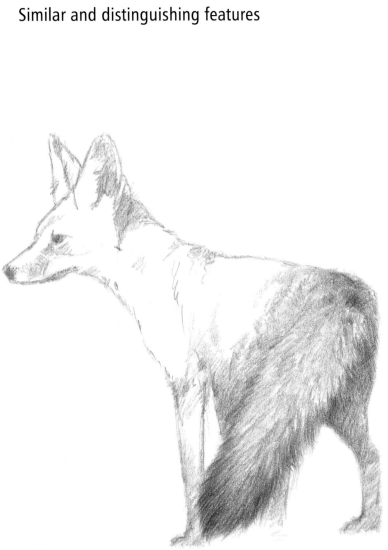

Ears
Large ears not only give the desert fox excellent hearing, but also help to dissipate the desert heat.

Tail
The thick bushy tail of the desert fox provides it with a warm 'blanket', which helps it to protect its muzzle from the cold desert night.

Desert fox in coloured pencils

1 As the desert fox is a nocturnal animal, the use of black paper automatically sets that overall evening/night tone. Use burnt sienna to establish the shape of the fox.

2 Switch to the cadmium orange coloured pencil and establish the highlights on the fox's tan-coloured fur. This suggests a setting desert sun, just as the fox is getting ready for a night's hunting.

3 The fur is usually a little darker along the back, and greyish in hue. Lay down some Prussian blue in this area.

4 Add a very soft white texture over the back fur using the titanium white coloured pencil.

5 Create the other highlights across the body with a mixture of Naples yellow and titanium white.

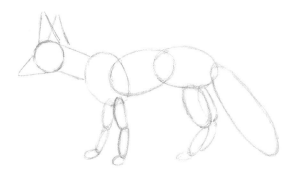

You will need

Smooth black drawing paper: 42 x 30cm (16½ x 11¾in)
Coloured pencils: burnt sienna, cadmium orange, Prussian blue, titanium white, Naples yellow

Basic shapes

The basic shapes are similar to that of the wolf, but with smaller body ovals. The desert fox has shorter legs, a smaller head circle, quite prominent triangle shapes for the ears and a more pointed snout than most other canids.

The finished picture.

COYOTE

The coyote (*Canis latrans*) is a smaller cousin of the grey wolf, evolving along a different line. Despite this, coyotes are sometimes mistaken for wolves, and indeed, their coats are quite similar in colour and texture; coyotes are sometimes referred to as prairie wolves. However, there are physical differences between the two sub-species.

Unlike wolves, whose numbers have declined through the expansion and intervention of human populations, coyotes have thrived. The coyote is intelligent, adaptable and resourceful, and is no stranger to populated urban areas in most of North and Central America.

Similar and distinguishing features

Below are the basic head shapes for a coyote (left) and a wolf (right). Putting the two next to each other allows us to compare them more easily, and begin to pick out the differences between the two species.

When the basic shapes are filled out more, these differences can be seen more clearly. Coyotes have considerably larger ears than wolves, and the muzzle of the coyote is narrower and more pointed.

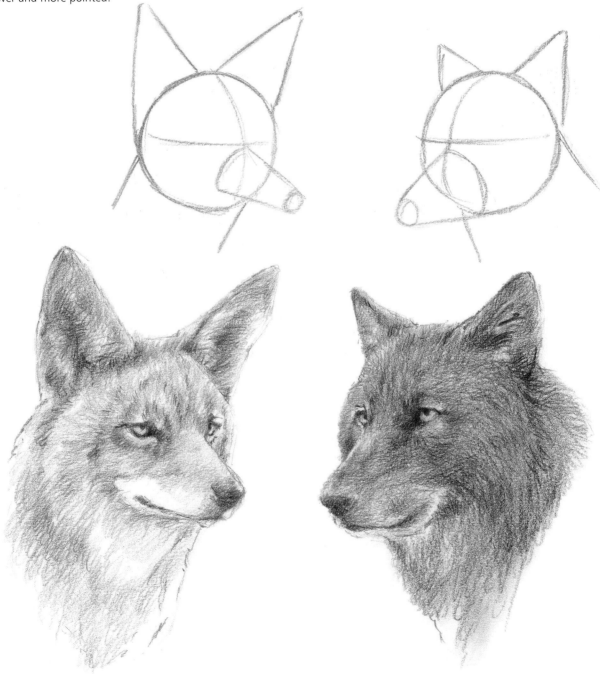

Coyote in acrylics

1 Using the 15mm (½in) short flat brush, tone the acrylic paper with a wash of burnt sienna.

2 With the same brush, loosely paint in the background mountains; the distant mountain is ultramarine blue with a touch of titanium white, while the mountain in the middle distance uses much less titanium white. Mid-distance foliage is established with layers of sap green.

3 Establish shadow tones in the coyote with burnt umber and ultramarine blue, still using the 15mm (½in) short flat brush. Use the same brush and mix to establish the shadows on the foreground rock.

4 Add colour to the eyes with the size 6 round brush and burnt sienna, then begin to pick out the details on the eyes, nose and mouth using the same brush with Payne's gray. Do the same with the fur texture in the shadows.

5 Create the highlighted fur texture with titanium white and the size 6 round brush.

6 Glaze over the texture in the darker areas using the 15mm (½in) short flat brush with burnt umber and ultramarine blue. Repeat two or three times to achieve the correct depth of colour.

7 Add the final details, such as the cactus and branches, with burnt umber, sap green and the size 6 round brush.

You will need
450gsm (210lb) acrylic paper:
 24 x 32cm (9½ x 12½in)
Acrylic paints: burnt sienna,
 ultramarine blue, titanium
 white, sap green, burnt umber
 and Payne's gray
Brushes: 15mm (½in) short flat,
 size 6 round

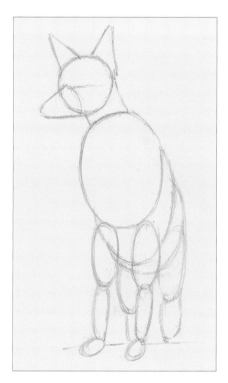

Basic shapes

At first glance, drawing this coyote's pose may look complicated, but if you draw the basic shapes carefully, any arrangement or position is possible.

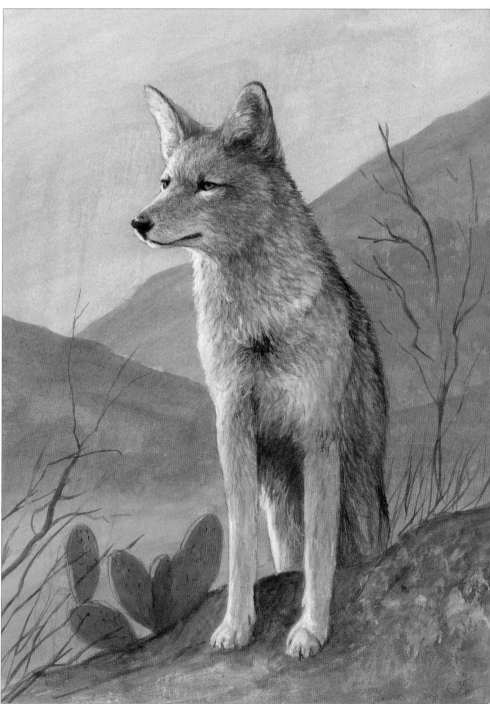

The finished picture.

AFRICAN PAINTED DOG

Also known as African wild dogs, Cape hunting dogs or painted wolves, painted dogs are one of Africa's increasingly endangered species. Their scientific name *Lycaon pictus* means 'painted wolf', but painted dogs are only distantly related to other canids.

African painted dogs have a reputation as cruel scavengers, a reputation which is not really deserved, as they are very intelligent, social animals, much like wolves. I personally find them very attractive animals, with their large round ears, dark faces and almost domestic dog-like expression. Most of all, however, it is their individually unique 'painted' coat pattern that I find amazing. Scientists are still undecided as to the purpose of such markings.

Similar and distinguishing features

The African painted dog is easily identified by its large, rounded ears, dark muzzle and, of course, its 'painted' mottling in brown, black, tan and yellow.

It is often a good idea to combine graphite pencil with coloured pencils when making your preparatory sketches, as seen in the example below. As you can see, this establishes tonal values as well as helping you to remember basic colours. The colours used here are Prussian blue, burnt sienna and Naples yellow.

Vic's tip

When sketching, try not to use an eraser. Your 'working up' marks will give your finished sketch more vitality. Sketches should be loose and full of energy.

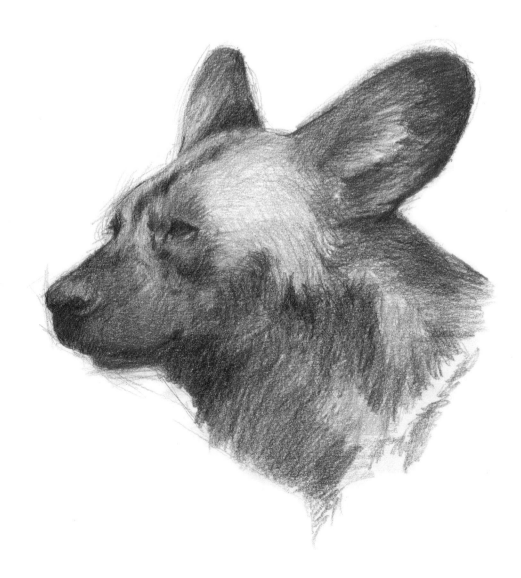

African painted dog in pastels

1 Sketch your preliminary outline and proportions on to the velour paper. Use a soft charcoal pencil; graphite pencils tend to indent the paper, and this will be difficult to remove at a later time.

2 Use the black hard pastel to create the tonal sketch – this should include slightly more defined features and outlines, and some basic shading.

3 Ignoring the dark markings of the painted dog and concentrating on the overall colour and texture, add some flat colours where visible – Prussian blue around the muzzle, and golden brown everywhere else except for the very light areas of fur, which should be covered with ivory.

4 Add further details and markings using the black pastel, before finishing with some ivory highlights. Pure white highlights would be too strong and cool for the overall tones of this sketch, and ivory is a more natural, warm colour.

You will need

260gsm (120lb) sand-coloured
 velour paper: 25 x 35cm
 (9¾ x 13¾in)
Hard pastels: ivory black, ivory,
 golden brown and Prussian blue
Soft charcoal pencil

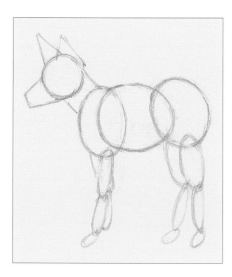

Basic shapes

The shapes of the African painted dog are similar to other canids. The muzzle, however, is more squared off than other canids – compare the basic shapes here with those of the coyote or desert fox.

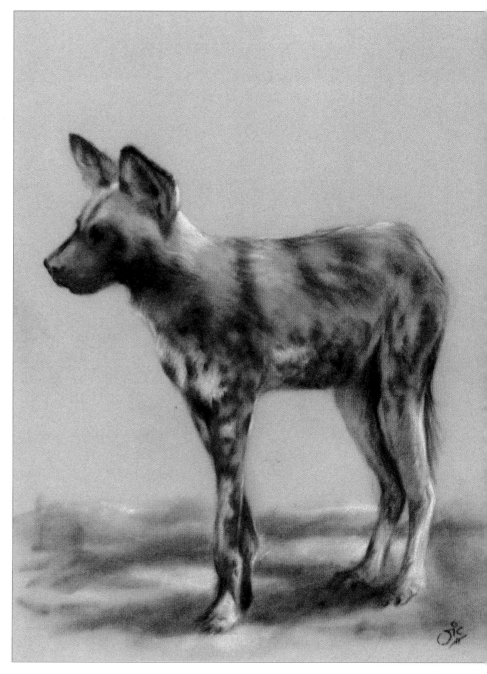

The finished picture.

Wolf

Wolves are fascinating, elusive animals, seen only rarely – and for fleeting moments – in the wild. In this project, I wanted to capture that moment as the wolf emerges from cover in a dark forest. The wolf in this painting is a dark-haired female, whose fur shines almost red-brown in the autumn light.

You will need

450gsm (210lb) acrylic paper: 25 x 35cm (9¾ x 13¾in)
Acrylic paints: burnt sienna, burnt umber, ultramarine blue, Payne's gray, titanium white, raw sienna and yellow ochre
Brushes: 15mm (½in) short flat, 7mm (¼in) long flat, size 6 round, size 6 synthetic round
Low-tack masking tape
Masking fluid and old brush
Drawing board and 2B pencil

1 Sketch the wolf and the basic background on to the acrylic paper using a 2B pencil.

2 Tone the paper with a dilute wash of burnt sienna using the 15mm (½in) short flat brush. Once the wash is completely dry, begin sketching out the basic shapes of the trees, using long strokes of the 7mm (¼in) long flat brush and dilute burnt umber.

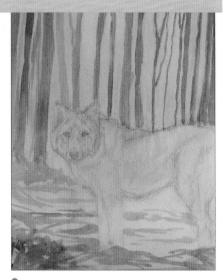

3 Using the same brush and paint, suggest the basic shapes in the foreground using loose strokes at varying angles.

4 Switch to the size 6 round brush and pick out the main shapes of the wolf herself. Aim to produce a tonal sketch by concentrating on the darker areas as shown. Suggest the texture of longer fur with short strokes.

5 Use the 15mm (½in) short flat brush to glaze the foreground with very dilute ultramarine blue, leaving the wolf untouched. Add more water to the paint to glaze the trees and background.

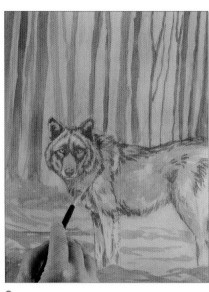

6 Switch to the 7mm (¼in) long flat and use a slightly stronger glaze of ultramarine blue to block in the areas of shadow and the cool-toned parts of the fur. Allow to dry.

120

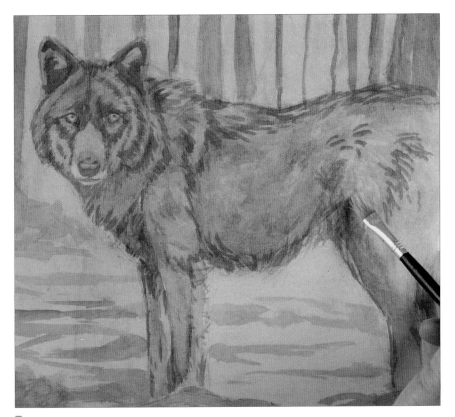

7 Using burnt umber diluted to a similar consistency, block in the warm-toned areas of the fur.

8 Allow the painting to dry completely, then use low-tack masking tape to cover the bulk of the wolf.

9 Use an old size 2 round brush to apply masking fluid to any exposed edges of the wolf. Allow the masking fluid to dry.

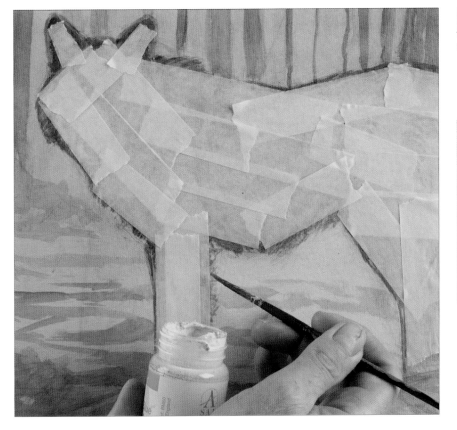

Vic's tip

The background, foreground and subject should be finished together to achieve a coherent successful image. Masking off the subject until the other elements are near to completion removes the worry about accidentally obscuring the subject; so that you can finish everything off together.

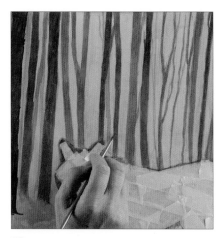

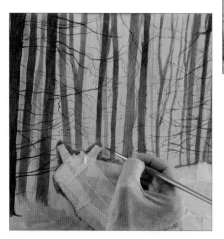

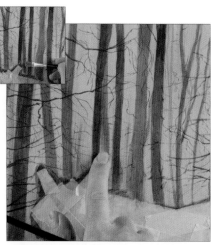

10 Using a size 6 round brush, add body to the trees with a fairly dark mix of burnt umber and Payne's gray. Vary this consistency, diluting the mix for the trees further into the background. To avoid unsightly gaps later, extend the brushstrokes on the trees slightly over the edges of the masking on the wolf.

11 Use the size 6 synthetic round to add in finer branches to the trees with the same colour. Be careful to match the consistency of paint you use for the branches to the tree to which you are adding them: use stronger paint for foreground trees and more dilute paint for background trees.

12 Using burnt sienna, paint in some vertical strokes with the 7mm (¼in) long flat (see inset), overlaying a few of the trees and suggesting new ones. Use your finger to to blend them gently into the surface while the paint is wet.

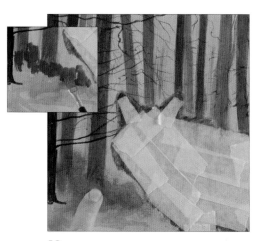

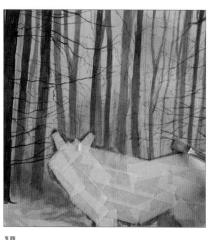

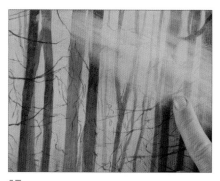

13 Using shorter, choppier strokes (see inset), add in some warm undergrowth at the base of the trees.

14 Suggest a warm glow around the centre with a glaze of dilute yellow ochre and the 15mm (½in) short flat brush.

15 Suggest diffuse light coming in rays from the top left, using the 15mm (½in) short flat brush and dilute titanium white. Work small areas at a time with angled strokes, then soften the paint in with your finger, working in the same direction as the brushstrokes.

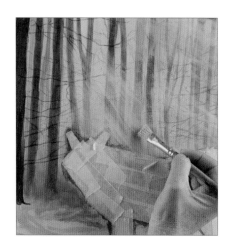

16 Continue creating diagonal lines of wintry light. Leave more defined edges near to the wolf by using longer brushstrokes and not softening them in.

17 Using long strokes and touches of the 7mm (¼in) long flat, suggest light between the trees on the left-hand side and in the undergrowth.

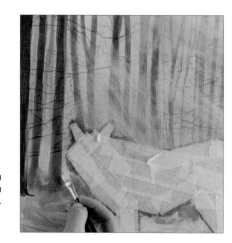

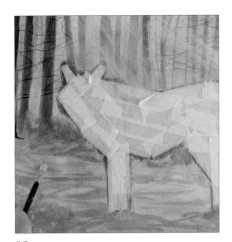

18 Use the 7mm (¼in) long flat brush to paint a glaze of ultramarine blue across parts of the foreground, representing the shadows in the underlying snow. Include the shadows of the foreground trees with vertical strokes.

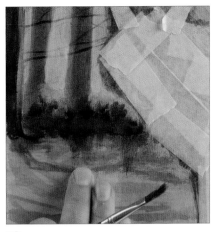

19 Use a mix of burnt umber and Payne's gray to add structure to the undergrowth. Draw your finger down directly beneath each tree to strengthen the shadow.

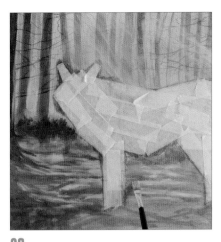

20 Create some exposed roots and soil in the foreground with the same mix and loose, horizontal strokes of the brush.

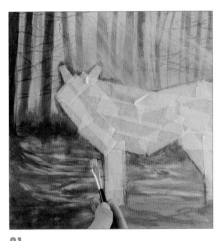

21 Add a little burnt sienna to yellow ochre and add scrub and grass in the foreground and the undergrowth on the left.

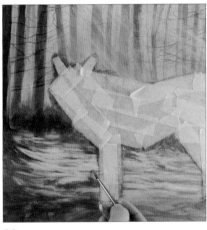

22 Add a touch of ultramarine blue to titanium white and use the size 6 round brush to add highlights to the snow.

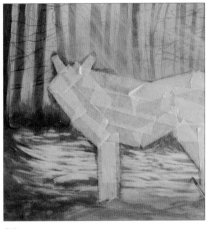

23 Create starker highlights over the same area with pure titanium white.

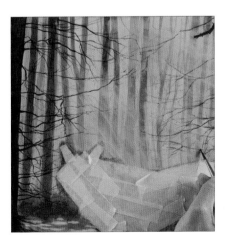

24 Develop the detail on the trees by reinforcing the foreground branches using the size 6 synthetic round brush with a mix of burnt umber and raw sienna.

25 Carefully remove the masking tape then use a clean finger to rub away the masking fluid from the wolf.

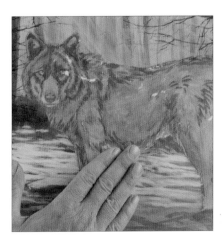

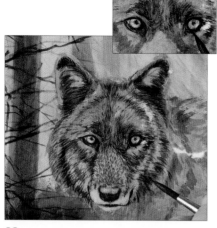

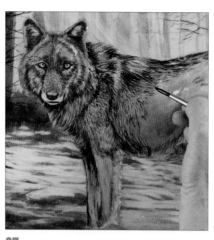

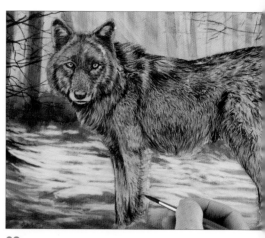

26 Start to develop the wolf's head and features using the size 6 synthetic round and a fresh mix of burnt umber and Payne's gray. Make very small marks with the tip of the brush to suggest the texture of fur (see the fur map on page 113 for guidance on the length and direction of the fur). Work carefully around the eyes, lining the top and adding circular pupils (see inset).

27 Start to work the fur over the rest of the body, using longer strokes with the side of the brush for the rougher fur on the neck and saddle areas, use many curt strokes for the shorter fur on the flanks and legs.

28 Continue building up the base layer of the fur until the whole wolf is covered.

Vic's tip

Take your time with these stages. The fur of a wolf is very complex.

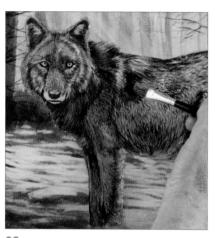

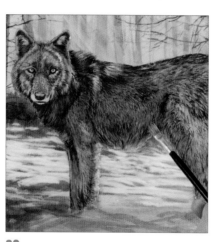

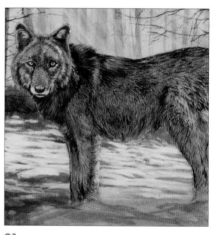

29 Using the 7mm (¼in) long flat brush and dilute burnt umber, glaze the area around the foreleg, neck and saddle areas, deepening and enriching the colours. Follow the contours of the body: use the direction of the fur strokes you laid in earlier to guide you.

30 Develop the back, flanks and hindquarters with this initial tonal wash, avoiding the lightest areas, as shown.

31 Glaze the light areas with dilute burnt sienna and the same brush.

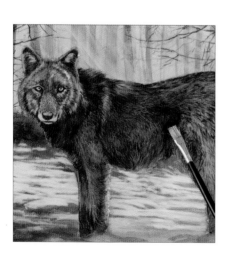

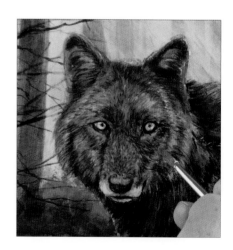

32 Glaze the recesses and shadow areas using a mix of burnt sienna and Payne's gray.

33 Change to the size 6 round and glaze the warm midtone areas of the head and face carefully with burnt umber. Use short strokes that follow the contours of the fur.

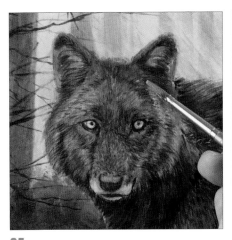

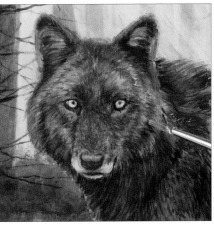

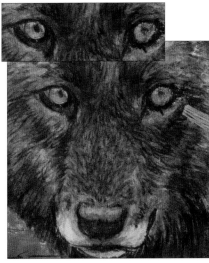

34 Glaze the areas of highlights with burnt sienna to add warmth on the wolf's head.

35 Dilute a mix of burnt umber and Payne's gray and use it to glaze the deepest shades.

36 Give the eyes a little warmth with dilute raw sienna (see inset). Once dry, glaze yellow ochre over the top.

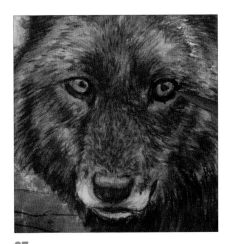

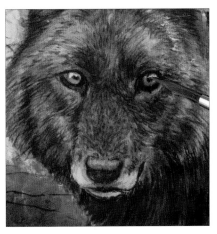

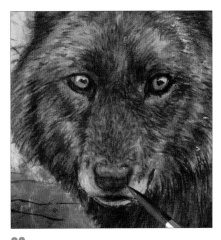

37 Sharpen the rims and pupils of the eyes with Payne's gray and the point of the size 6 synthetic round brush.

38 Add a tiny sharp point of reflected light in each eye using titanium white, to suggest the glossiness.

39 Glaze the nose, mouth and muzzle with very dilute ultramarine blue.

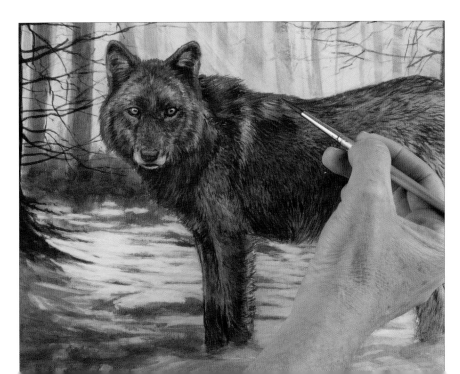

40 Warm the backlit fur at the edges of the wolf with subtle touches of burnt sienna applied using the size 6 synthetic round brush.

41 Complete the foreground with a mix of burnt umber and Payne's gray using the size 6 round brush for large branches and the size 6 synthetic round brush for smaller twigs. These very dark parts help to create a sense of depth in the finished painting.

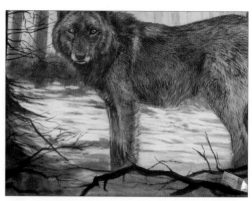

42 Darken the lower corners with a dark glaze of Payne's gray with a little burnt sienna, applying the paint with the 15mm (½in) short flat.

43 Suggest snow on the foreground branches with the size 6 round brush and a slightly diluted titanium white and ultramarine blue mix.

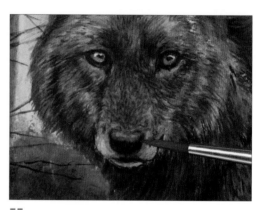

44 Use the dark glaze (Payne's gray with a little burnt sienna) to deepen the shadows under the eyelids and nose.

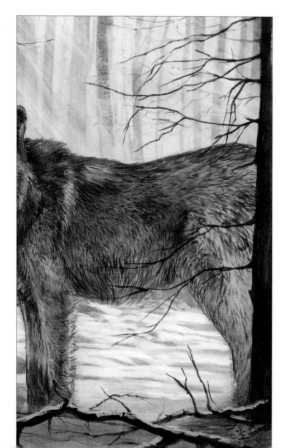

45 Use a size 6 round brush with a mix of Payne's gray and burnt umber to connect the sections of the trunk on the right-hand side, bringing it into the foreground. This has the effect of knocking the wolf back, which increases the depth of field.

Opposite
The finished picture.

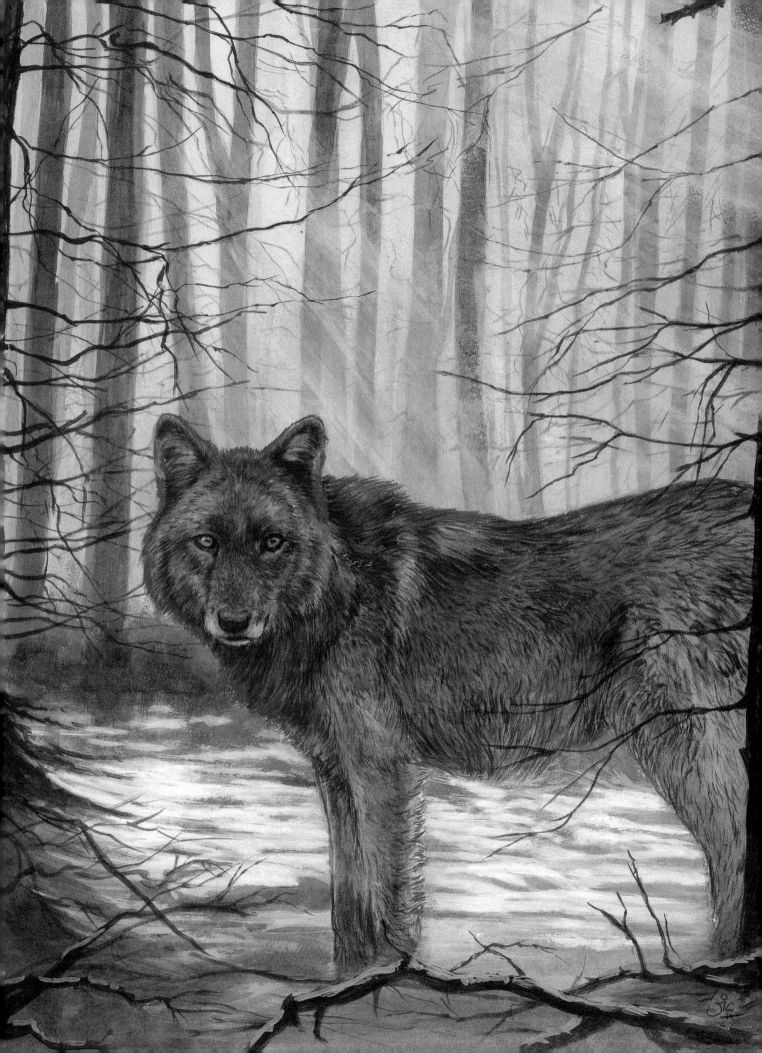

Index

Ring-tailed Lemur

This acrylic painting of a ring-tailed lemur was worked on dark green mountboard.